WALL STREET NUMBER

Volume 78 Copyright, 1921, Life Publishing Company Number 2025

SEPTEMBER 22, 1921

Life

PRICE 15 CENTS

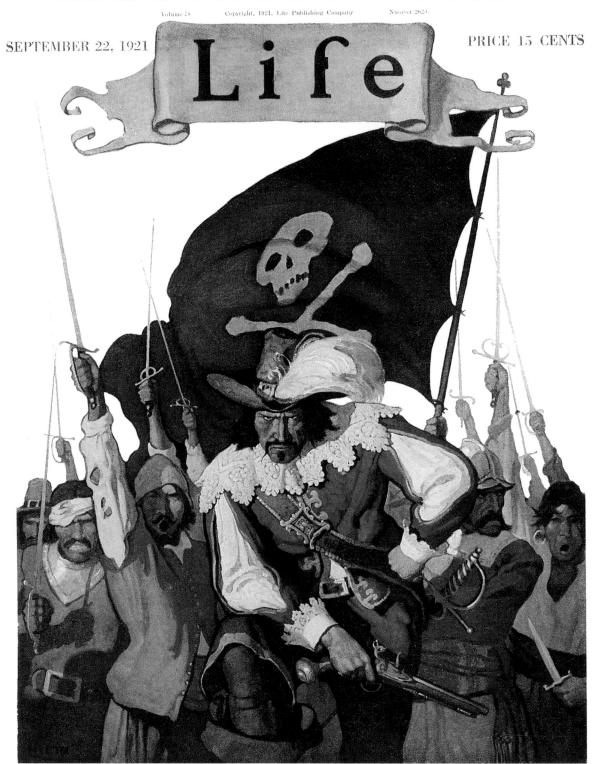

"Stand and Deliver!", N. C. Wyeth's lone cover for *Life Magazine*, September 1921

N. C. WYETH

GREAT ILLUSTRATIONS

Edited and with an Introduction by Jeff A. Menges

DOVER PUBLICATIONS, INC.
Mineola, New York

Bibliographical Note

This Dover edition, first published in 2011, is an original compilation of N. C. Wyeth illustrations reprinted from various sources.

Library of Congress Cataloging-in-Publication Data

Wyeth, N. C. (Newell Convers), 1882–1945.
 Great illustrations by N. C. Wyeth / edited and with an introduction by Jeff A. Menges. — Dover ed.
 p. cm.
 Original compilation of N. C. Wyeth illustrations reprinted from various sources.
 Includes bibliographical references.
 ISBN-13: 978-0-486-47295-9
 ISBN-10: 0-486-47295-7
 1. Wyeth, N. C. (Newell Convers), 1882–1945—Themes, motives.
 I. Menges, Jeff A. II. Title.
NC139.W93A4 2011
741.973—dc22 2011013839

Manufactured in the United States by Courier Corporation
47295702
www.doverpublications.com

Dedicated to
THE KNIGHTS OF JORDAN ROAD
Their appreciation for adventure and a good tale
certainly planted the same in me.

Contents

FRONTMATTER ILLUSTRATIONS

TITLE PAGE: Vignette from *Westward Ho!,* Charles Scribner's Sons, New York, 1920

DEDICATION: Chapter head from *The Courtship of Miles Standish,* Houghton Mifflin Company, Boston and New York, 1920

THE PLATES: Chapter head from *The Pike County Ballads,* Houghton Mifflin Company, Boston and New York, 1912

TAILPIECE: From *The Pike County Ballads,* Houghton Mifflin Company, Boston and New York, 1912

Introduction

THERE were scores of talented illustrators who worked prolifically in the early part of the twentieth century. Work was plentiful, and the field of illustration was developing faster than the work could be done. Most of those artists are remembered today as little more than footnotes in dusty publications. A few of them—very few—have names that have transcended their station. In the 1890s, Charles Dana Gibson created a character of ink lines, "The Gibson Girl," who would lead fashion trends and become a portrayal of the feminine ideal. In the mid-twentieth century, Norman Rockwell depicted decades of American life with a small-town feel. For most of the first half of the century, N. C. Wyeth created dramatic story illustrations that set visual standards. Wyeth defined what characters like Long John Silver and Merlin looked like, and created the iconic costumes for *Robin Hood* and *The Last of the Mohicans*—even though the stories had been illustrated by many others before. Wyeth's strong characters, vivid colors, and moments of tension are what most viewers remember best about these images.

In 1902, at the age of nineteen, Newell Convers Wyeth traveled from his Needham, Massachusetts, home to meet and study with Howard Pyle in Wilmington, Delaware. The father of "The Brandywine school," Pyle was arguably the most important and influential illustrator of the day. He crusaded to make

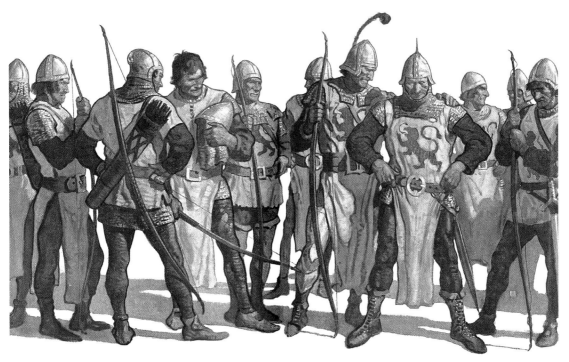

Endpapers, *The White Company*,
Cosmopolitan Book Corporation, New York, 1922

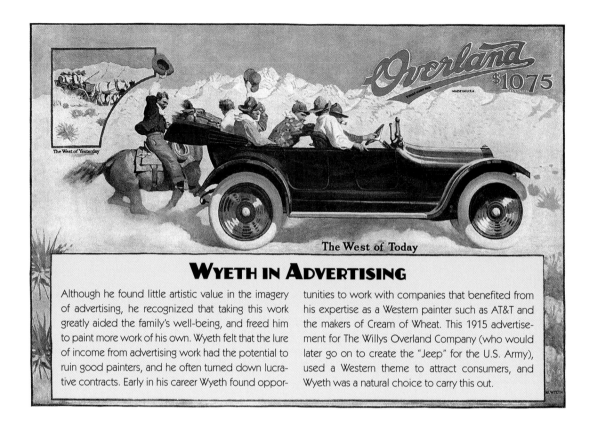

WYETH IN ADVERTISING

Although he found little artistic value in the imagery of advertising, he recognized that taking this work greatly aided the family's well-being, and freed him to paint more work of his own. Wyeth felt that the lure of income from advertising work had the potential to ruin good painters, and he often turned down lucrative contracts. Early in his career Wyeth found oppor-tunities to work with companies that benefited from his expertise as a Western painter such as AT&T and the makers of Cream of Wheat. This 1915 advertise-ment for The Willys Overland Company (who would later go on to create the "Jeep" for the U.S. Army), used a Western theme to attract consumers, and Wyeth was a natural choice to carry this out.

illustration "an art form," and to raise its quality through singlehandedly training a group of selected students. When Pyle interviewed a young N. C. Wyeth, he knew immediately he had found real potential. Wyeth joined the Howard Pyle school, and quickly rose through the ranks to became Pyle's star pupil. Pyle reviewed his students' work, helped them get their first clients, and in some cases, acted as an agent of sorts. It was Pyle who suggested that Wyeth make a trip out West in 1904—so Wyeth could learn firsthand about cowboys and their surroundings. The West would come to dominate Wyeth's subjects for the next decade, making him highly sought-after and his art a part of every major magazine of the day.

After completing his studies with Pyle and returning from his Western expedition,

Wyeth settled into life in the Wilmington area. In 1906 he married Carol Bockius. They would later build a home and studio at nearby Chadds Ford, Pennsylvania. Wyeth's family with Carol would grow to number five children, with whom N. C. spent a considerable amount of time. A fervent letter-writer, Wyeth remained in constant contact with his mother throughout her life, and such strong parent-child relations would transfer down to his own children, three of whom—Henrietta, Carolyn, and Andrew—would go on to become painters in their own right. The Wyeths called the Chadds Ford area home for the rest of Wyeth's life, though he would occasionally return to the Needham homestead to visit his mother. Around 1920, Wyeth bought an old Captain's cottage in Port Clyde, Maine, with fellow Pyle School alumnus, Sidney Chase.

This would become the family's summer retreat, and the subject of a great deal of Wyeth's later paintings.

Wyeth's career turned a corner in 1911, when Scribner's publishing house approached him to do an illustrated edition of Robert Louis Stevenson's *Treasure Island,* with seventeen color plates. He had done some plate books before, but none so complex, and none that had inspired him to this degree. The paintings were completed in late July 1912, and by that October the book had become a total success. The book set a new standard, and the combination of Scribner's Classics with Wyeth's images yielded sixteen volumes over a period of nearly thirty years.

Wyeth perceived his artistic career with mixed feelings at times. On the one hand, he felt satisfied with the set of canvases that he sent to Scribner's, but he often yearned for appreciation outside of publishing. After a decade of being a leader in American illustration, Wyeth began to feel that this was not the kind of legacy he wanted to leave behind. Even during his studies with Pyle, Wyeth had sought recognition as a painter. Between assignments he would produce studies, landscapes, or an occasional still-life. He longed to be known as a painter, not as an illustra-tor. He saw illustration as a product of a commercial need, and thought that little would be remembered of an illustrator's work—but Wyeth did see the benefits. Illustration provided financial security for his family, and by taking on each large new project, he would have a substantial amount of time to pursue his own artistic goals. That cycle of painting for himself, alternating with illustration assignments, would continue for most of Wyeth's career.

Wyeth went on to produce more easel paintings later in his career. Some of his commercial commissions came in the form of mural work for large hotels and state houses. Wyeth's first one-man gallery show in 1939 was for the easel paintings that he'd longed to see succeed. Though not critically acclaimed as a painter in his lifetime, Wyeth has finally acquired the prestige that he had always sought. His paintings as well as his illustrations are now finding their place in museums. Pyle's mission of creating an art form from illustration has achieved some strong footholds nearly a century later. Works by many Brandywine artists, Wyeth perhaps first and foremost, have since found both academic and popular acceptance, and have attracted buyers at the highest levels.

JEFF A. MENGES
March 2011

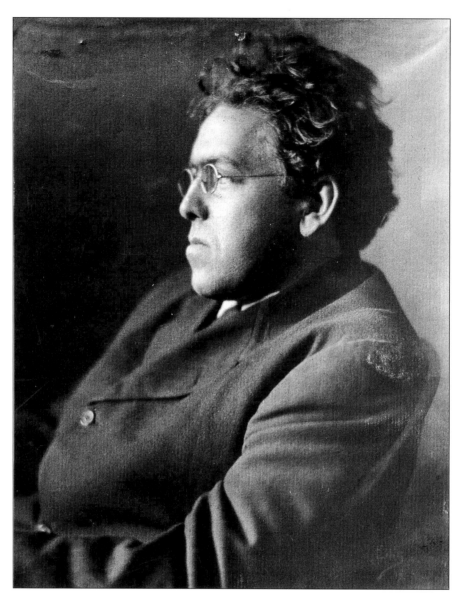

N. C. Wyeth, circa 1916

For Better Illustration

By N. C. Wyeth

Originally appeared in Scribner's Magazine, November 1919

While researching the broad scope of illustration work presented in this volume, this article surfaced among the imagery. Being written by N.C. Wyeth himself, on the subject at hand, it seemed more than fitting to include his voice on the topic.

MOST of us will agree, I presume, that American illustration, considering the remarkable opportunities that have been offered by the publishers, in the past twenty years, is not up to the standard of excellence which we have every right to expect, and the quality of production does not seem to grow more important as the time passes. Here and there we find admirable pictures no doubt, but considering the mass of drawings that are being made, the number of good works is almost negligible; and even the best too often lacks potentiality, that promise of *growth into* the broader field of painting and mural decoration which is the logical sequence to illustration.

Let us glance at present methods and circumstances which I think are interfering with the production of substantial illustrators, and then propose a few corrective suggestions which I believe to be fundamental.

The popular blame for the failure of the modern illustrator is, of course, laid upon the tremendous and enveloping spirit of commercialism, and unquestionably this does play a large part in his undoing. However, commercialism is a condition, and it must be met. But I feel by stopping here that we are missing the real issue and are not striking at the source of our failures.

There is a very depressing belief in artistic circles, particularly amongst the painters themselves, that illustration is not an art but a craft, that it is not conceived from inspirational sources, but is built and fashioned as a stage-setting would be around the theme of a story, or planned like an ingenious design. Now it happens that the painter's opinion in this matter has far-reaching and distressing results for the illustrator, as it is he who stands at the advisory head of our art training-schools and, consciously or unconsciously, establishes the standards, and shapes the policies and methods therein.

To my very definite knowledge, the painter's opinion of the illustrator's profession as compared to his own, is often very near that of contempt, and if it amounted only to this I would have nothing to say; but his influence in the art academies is really the fundamental cause of a very serious neglect in the courses of training meted out to the illustrators, and this in spite of the fact that the illustrating classes have become a popular and paying branch of these institutions.

It has been my experience in the past few years to discuss the plans and prospects of a considerable number of art students aspiring to illustration. Many of them have come to me fresh from the art schools with the ostensible purpose of carrying on their study to more practical ends. From these contacts I have learned from the truest source possible just what the illustrator is getting from the academies.

We all realize that the period of adolescence in the life of the young artist or poet, when he is awakening into dreams of artistic achievement, while he is enjoying the subtle but none the less definite thrills of an inner urge to express himself, is the most wonderful, the most illusive, and the most susceptible period of his life. Now, unless this young spirit is blest with understanding parents who recognize, and are willing to cherish and foster this tender dawning of a new vision with the right supplementary training in the home, there remains no other provision for the proper development of his talent but to send him to an art school. So, invariably he is taken from the discipline and the mildly philosophical influences of the public schools, and is thrust into a school where there is still less of these things.

His first experience is to be seated before a cast, and with a few elementary remarks on drawing from the instructor, his work is started for the term. Now, outside of the weekly or semiweekly returns of the instructor the boy is allowed almost complete freedom to work or not, according to his moods, with no steadying influences of an intellectual nature, no one to remind him that *art* and *life* are incorporate, that to grow in artistic power he must grow in character. On the contrary, the philosophic ideas which he picks up are gleaned from the other students, older students, indiscreet students, the product of their loose surroundings. He is plunged almost immediately into a whirlpool of shapeless, radical ideas (so abundant amongst art students). It is not long before he has lost complete sight of his early, inherent vision, and has accepted in its place the novel, more exciting schemes upon which to shape his destiny. This is so often the beginning of the end. Only rarely does a fortunate student happen upon a helpful mind, one sufficiently strong and sympathetic to help him back into the real light. Back in the golden days of art an air of great seriousness, of religious fervor, surrounded the training of the artist; the profession was closely linked with the church, and to a very great extent supported by it, so when one entered the field, it was done with becoming reverence and humility which preserved a most fertile condition of mind for spiritual as well as technical growth. But to-day we have not the church, nor have we supplied any substitute to invest the profession with these inspirational qualities.

Now to speak more specifically of the prevailing system of teaching. The great majority of the art schools mark a distinct division between the painting classes and the illustrating classes. This is a grave mistake. The training course for the illustrator should not be one whit different or less thorough, than that for the painter. But it is a fact that the course of study required of the illustrator is depressingly brief. He is fairly galloped through the antique, takes a "swipe" at still-life painting, and bounces in and out of the life class. And heaped upon this slovenly drilling are the highly distracting interests of *composition*. Apply this system of training to the young musician, allow him to compose before he knows the five-finger exercises. The cases are precisely parallel.

Why the fallacy of precipitating a young, undeveloped mind into the advanced courses of an illustrating class before he has had a chance to occupy his senses sufficiently with the truth, and nothing but the truth, to acquire a thorough working knowledge of nature in her simplest forms, before attempting to present her in the impressionistic dressings of his emotions, is more than I can comprehend. To destroy individuality, seems to be the main function of the illustrating classroom to-day.

To turn the embryo mind face to face with technical methods, style, and the restrictions of publishing processes which all figure so prominently in composition, before he is able to feel that divine urge which comes only from a sound initiation into nature's truths is, to my mind, the principal reason why such a tragic percentage of art students fail.

I know from experience what it means to answer that premature call for pictures. The second week I spent in an art school I was requested to do this as a part of the routine, and how I suffered for that entire year. I noted that cleverness was rewarded; stunty and affected methods got the applause; so naturally I concluded that my salvation in art lay in my ability to develop a new *stunt*. And how many hundreds of promising young men are making this same mistake in our art schools to-day! To be sure, the crafty ingenuity of a few survives to reach a popular level—they enjoy a vogue, but invariably such ability grows weaker as time goes by, and finally passes out altogether. There is no substance, no body to such work, it is a mere shell, and being solely dependent on superficial effect the light of inspiration soon burns out.

I will admit the commercial value of such craftsmanship, but it does not figure at all in the building up of important illustration, and that is what I am writing about.

Now this brings me to that dire need of philosophic influence in the art schools, a phase of study which should be made as important a part of the curriculum as drawing or painting.

One has but to talk with any of the major-

ity of students to soon learn that they consider art something that they do rather than something they live. They are essentially dilettantes.

It seems to me that the first responsibility to be taught the young artist, along with sturdy technical study is this, that he must sense deeply of the fact and substance of the object he is drawing; he must learn to love that object for its own sake, not because it is picturesque, or odd, or striking, but simply because it is an object of form and substance revealed to him by the wonder of light that represents a phase of the great cosmic order of things.

My grandfather, who was associated with Louis Agassiz for many years, used to tell me that this was the very keystone to his power of teaching. He invested natural science with such a profound spirit of romance, and his thrilling appreciation of cosmic relationship was so strong, that he awakened the youngest of his listeners to the most enthusiastic appreciation of science. To the master this power to sense reality is an instinctive trait, of course, but how can this feeling ever live in a man who has never established stirring relations with the realities in the first place? The fact is the student is inclined and encouraged to look upon the phenomena of life as merely fit or unfit material with which to construct clever pictures. The result: they never reach the point where the creation of a picture becomes a constitutional necessity, but rather amounts to a mere intellectual attainment—the one vital, the other ephemeral. To unfold to the young mind the glory of all facts of existence should be the fundamental function of the art school, but in just this they are utterly deficient.

The view-point I have expressed, once established, the young artist will naturally become more interested in the common objects around him, and this is apt to save him that futile chase for ultra-picturesqueness in the shape of Dutch windmills, or South Sea Island cannibals, but instead he will derive his inspiration from the happenings in his own life, the virility of it passing without waste into his work. It was Thoreau who believed (and came as near to fulfilling his belief as any one ever did) that the action of doing a thing, and the writing about it should be so close that they amount to one and the same thing. And so with the picture-maker.

But isn't it obviously clear how the very training we get in the art schools, and colleges too, tends to separate us from life, teaches us to work too much with our brains and too little with our hearts? Romain Rolland in "Jean Christophe" says: "Write the simple life of one of these simple men, write the peaceful epic of the days and nights following one like to another, and yet all different, all sons of the same mother, from the dawning of the first day in the life of the world.

Write it simply, as simple as its own unfolding. Waste no thought upon the word and the letter, and the subtle vain researches in which the force of the artists of to-day is turned to naught. You are addressing all men; use the language of all men. There are no words noble or vulgar; there is no style chaste or impure; there are only words and styles which say or do not say exactly what they have to say. Be sound and thorough in all you do; think just what you think, and feel just what you feel. Let the rhythm of your heart prevail in your writings; the style is the soul."

We cannot, in art, produce a fraction more than what we are. The strange and popularly accepted belief that great artists were invariably wayward, and are excused for it on the grounds of special privileges, is as false as it is impossible. No great artist ever thrived on such principles. If stories have been handed down to us of moral lapses in the lives of the masters, their work survives in spite of the mistakes, and not on account of them. No art justifies anything but honest, straightforward living. The moral superiority of Beethoven, the greatest of them all, comes to my mind while I write this.

Do we hear any of this in the art schools? Decidedly no.

To teach the young illustrator that his salvation lies within himself, that to be able to draw virile pictures means that he must live virilely; upon such stuff should the system of the art schools be built. And without it we cannot expect him to be of any permanent benefit to the upbuilding of American illustration.

N.C.W.

The Plates

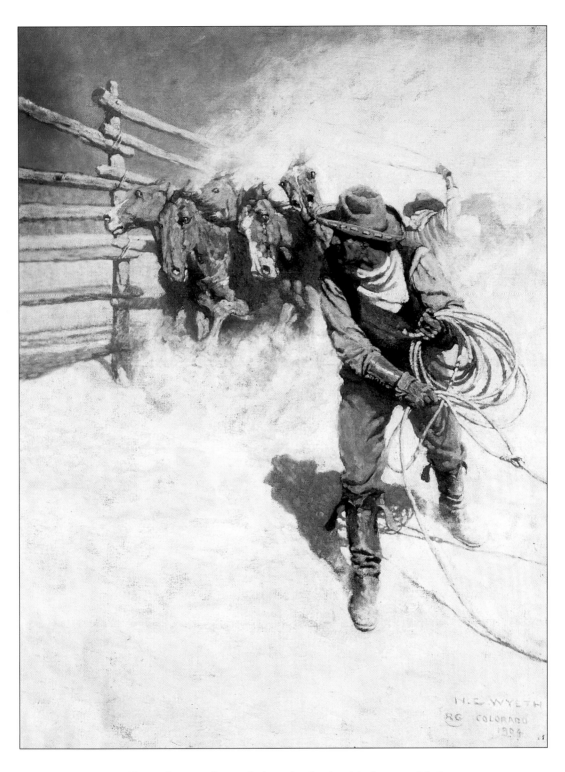

Above the sea of round, shiny backs the thin loops swirled.
"A Day with the Round-Up," *Scribner's Magazine,*
March 1906

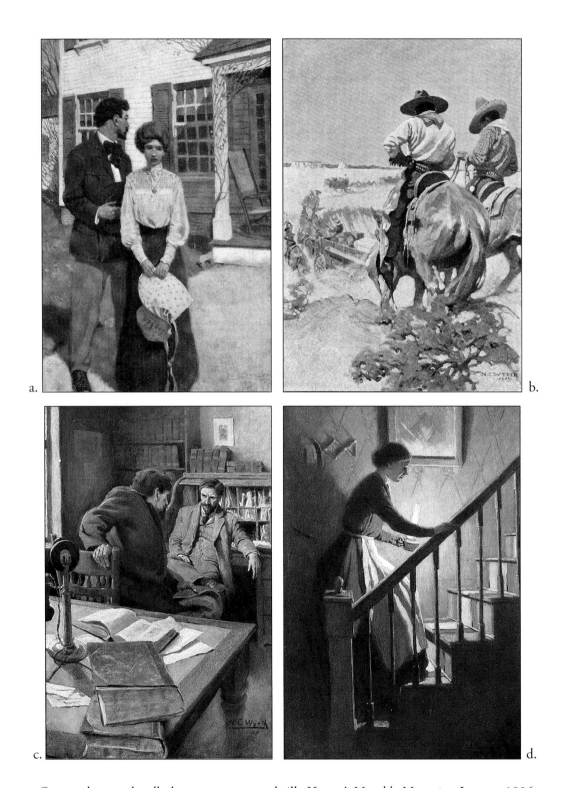

a. Out on the gravel walk they came to a standstill. *Harper's Monthly Magazine,* January 1906

b. "We joined the second expedition." "Arizona Nights," *McClure's Magazine,* March 1906

c. "There is one thing better than money—and that is a human home." *Harper's Monthly Magazine,* August 1905

d. He heard her sob her way up-stairs. *Harper's Monthly Magazine,* August 1905

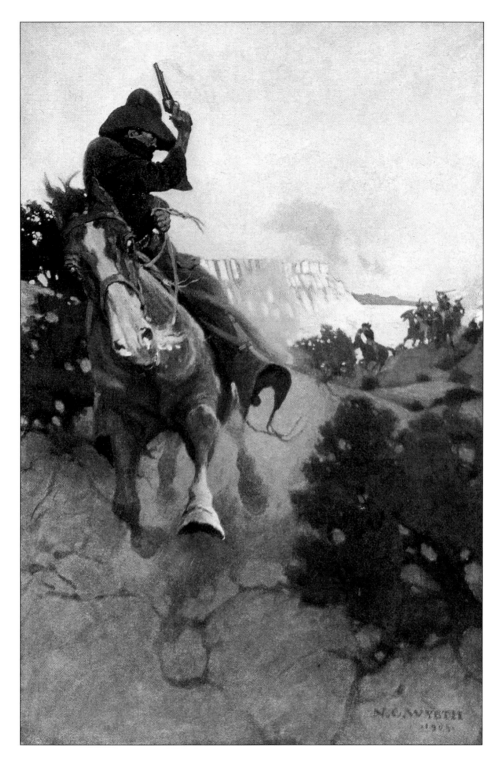

An almighty exciting race. "Arizona Nights," *McClure's Magazine,*
March 1906

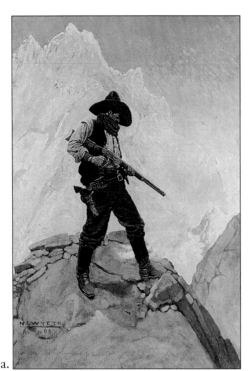

a.

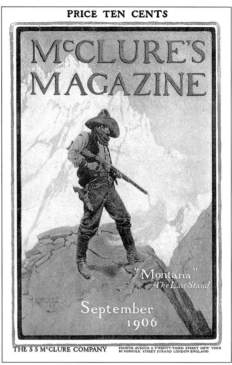

b.

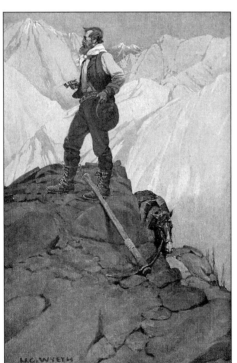

c.

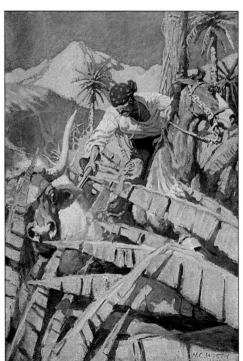

d.

a. The Last Stand. *McClure's Magazine,* September 1906
b. As the cover actually appeared.
c. The Prospector. *McClure's Magazine,* September 1906
d. The cattle killers were the original cowboys of America. *The Outing Magazine,* August 1906

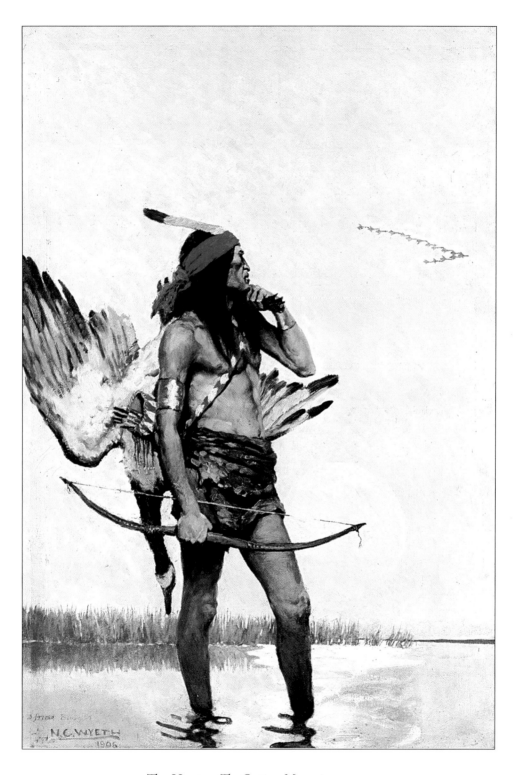

The Hunter. *The Outing Magazine,* cover,
June 1907

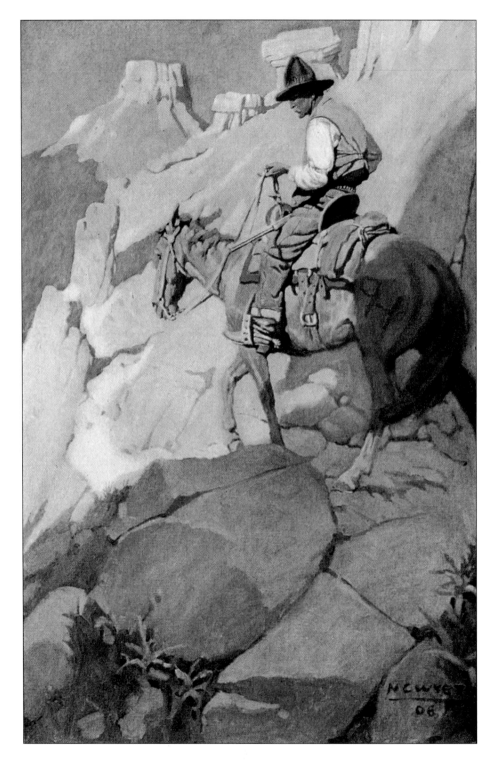

Following the trail itself, Whispering Smith rode slowly. *Whispering Smith,*
Charles Scribner's Sons, New York, 1906

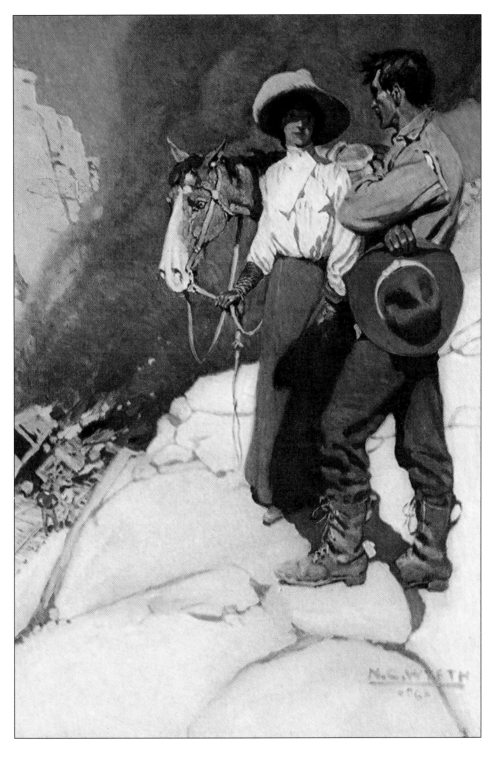

"And whom may I say the message is from?" *Whispering Smith,*
Charles Scribner's Sons, New York, 1906

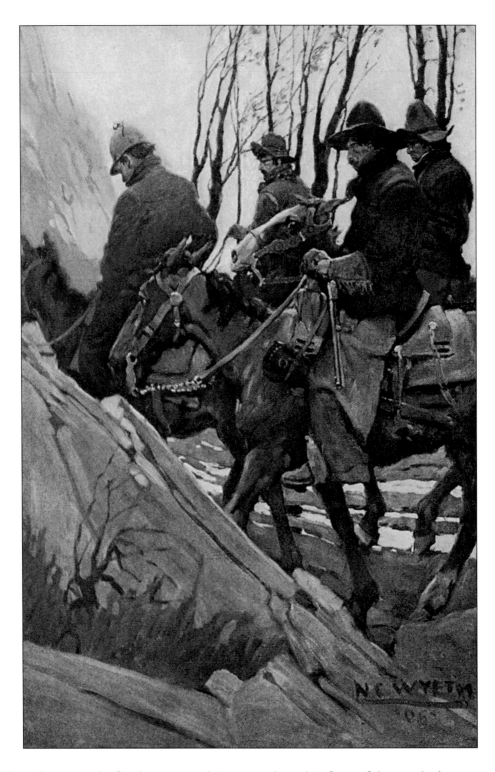

These three carried rifles slung across their pommels, and in front of them rode the stranger.
Whispering Smith,
Charles Scribner's Sons, New York, 1906

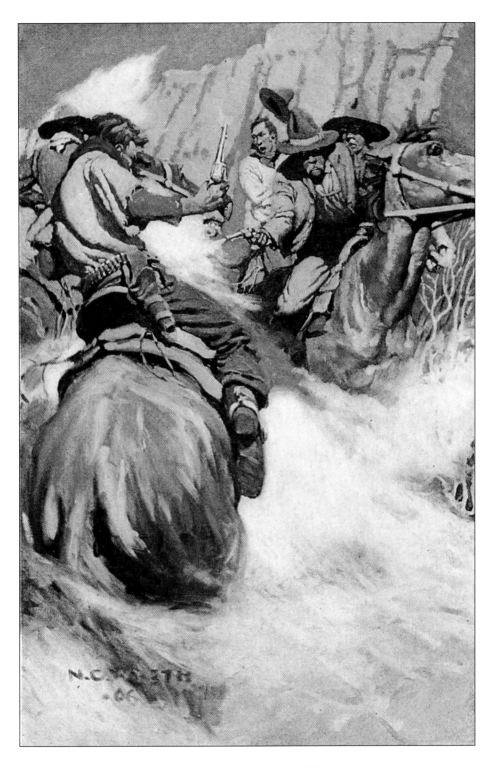

Wheeling at arm's length, shot again. *Whispering Smith,*
Charles Scribner's Sons, New York, 1906

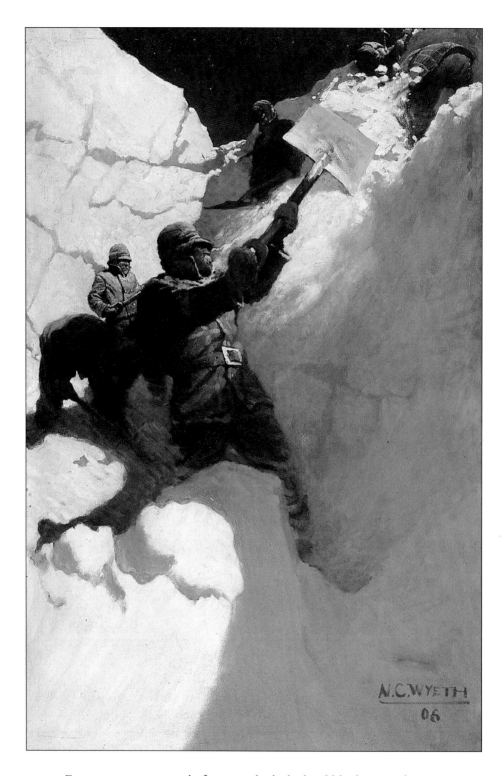

From an upper snow platform to which the hard blocks were thrown,
a second man heaved them over the bank. "How They Opened the Snow Road,"
The Outing Magazine, January 1907

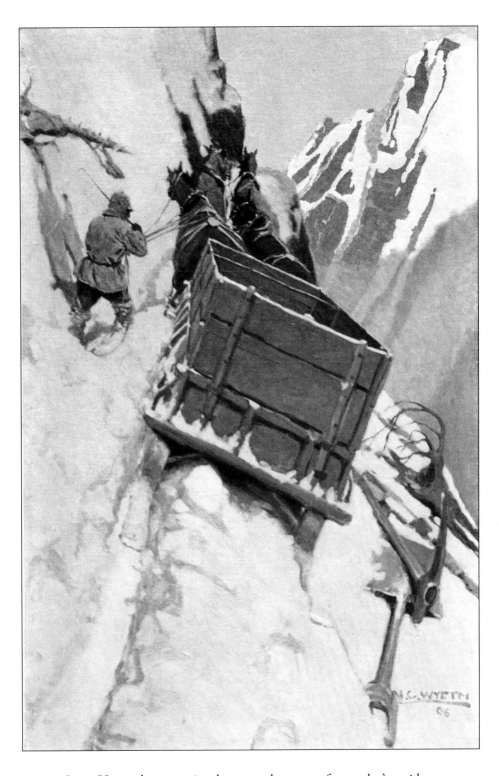

Long Henry drove cautiously across the scene of yesterday's accident
and up the approach to the rocky point. "How They Opened the Snow Road,"
The Outing Magazine, January 1907

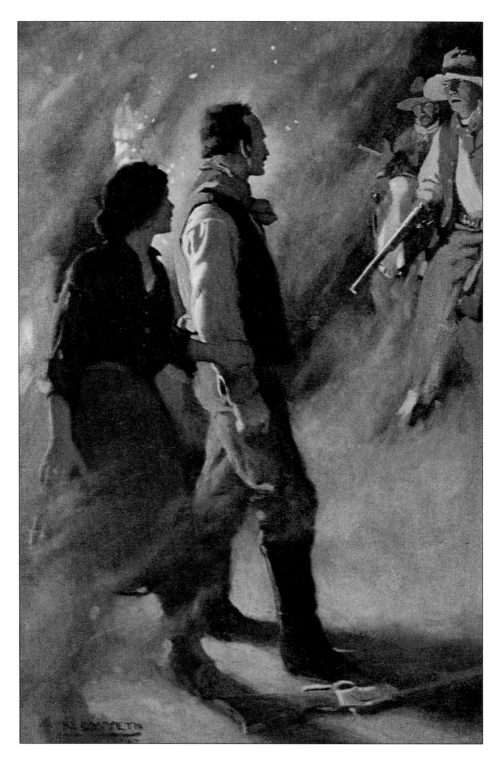

"I take it I am the One Wanted," Said Williston. *Langford of the Three Bars,*
A. C. McClurg & Co., Chicago, 1907

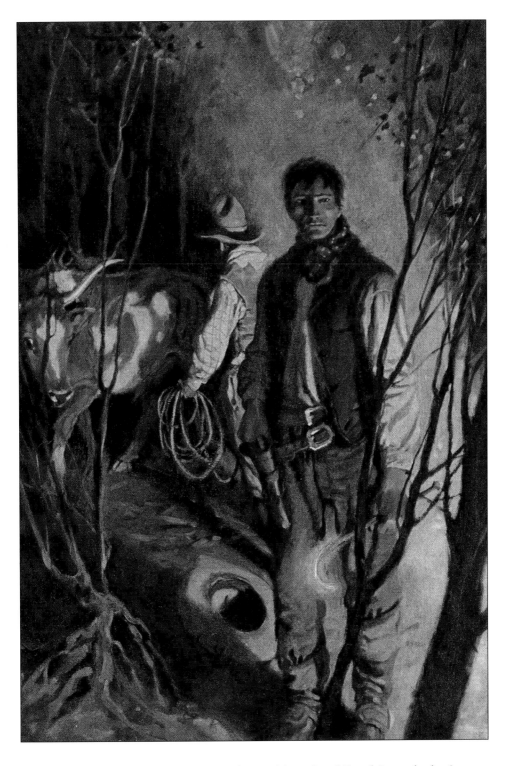

The Glowing Iron Stick in His Hand, Jesse Turned and Faced Squarely the Spot which Held the Watching Man. *Langford of the Three Bars,* A. C. McClurg & Co., Chicago, 1907

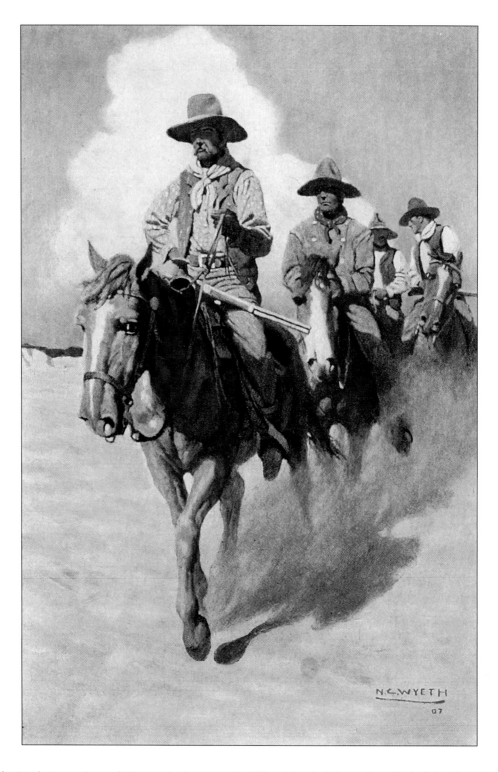

The Little Posse Started Out on its Journey, the Wiry Marshal First. *Langford of the Three Bars,*
A. C. McClurg & Co., Chicago, 1907

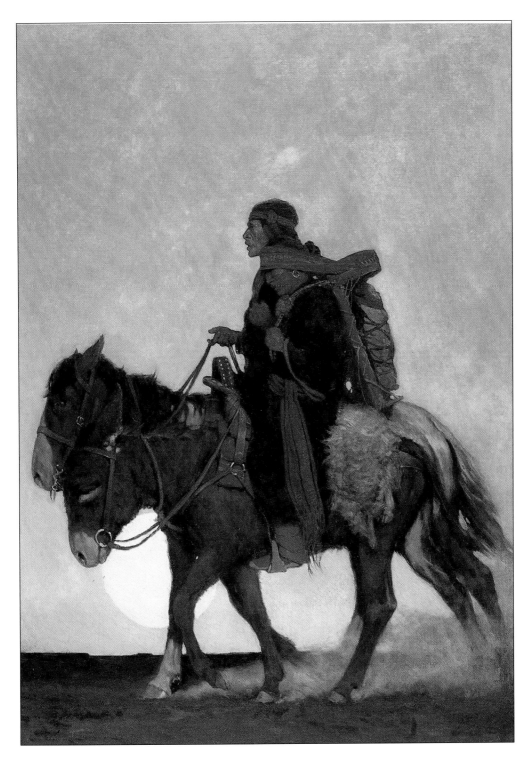

On the October Trail (A Navajo Family). *Scribner's Magazine,* October 1907

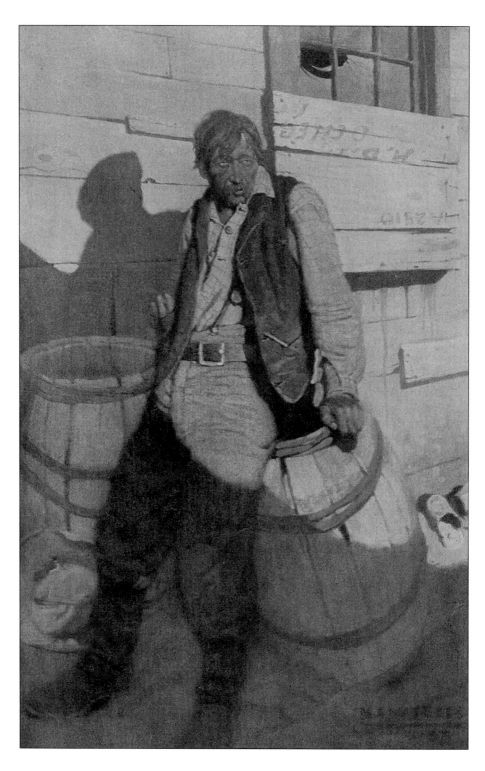

"I've sold them Wheelers!" "The Misadventures of Cassidy,"
McClure's Magazine, May 1908

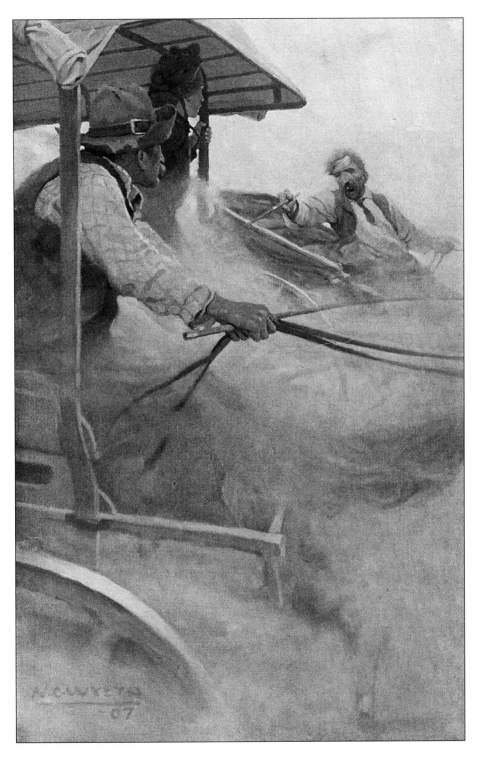

"I hereby pronounce you man and wife!" "The Misadventures of Cassidy,"
McClure's Magazine, May 1908

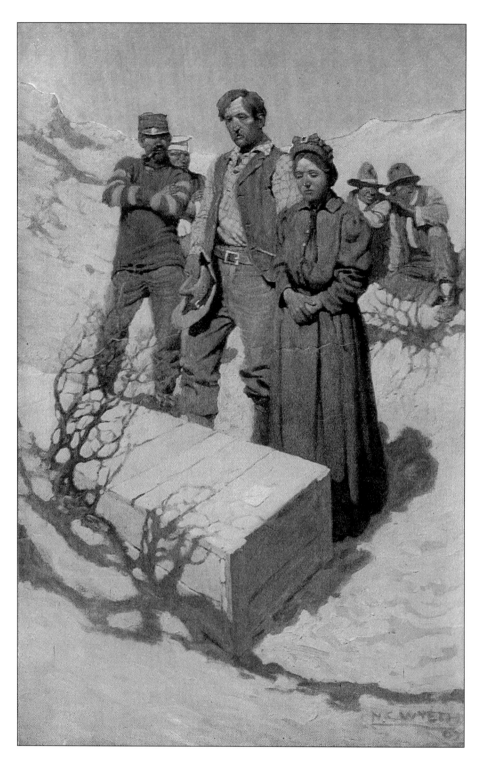

Nearest to the rough pine box stood the widow, with lowered eyes.
"The Misadventures of Cassidy," *McClure's Magazine,* May 1908

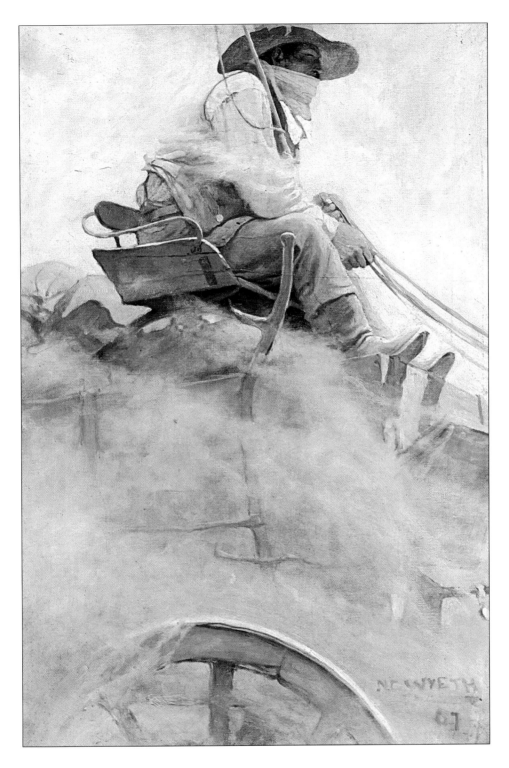

The Ore Wagon. "The Misadventures of Cassidy,"
McClure's Magazine, May 1908

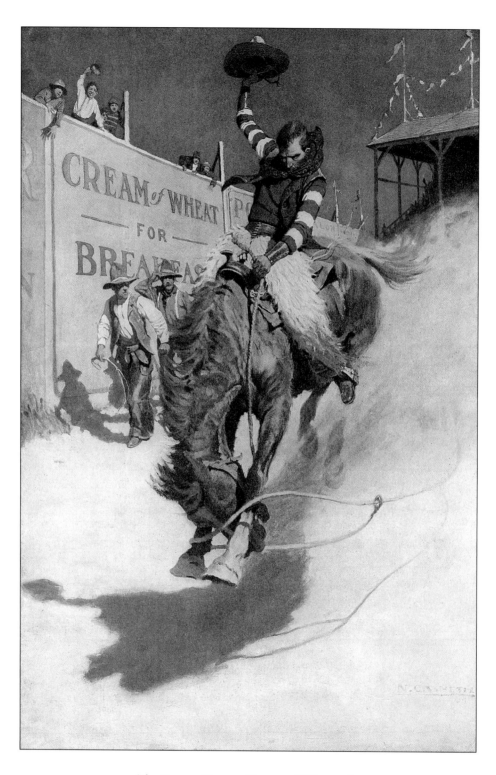

The Bronco Buster, Cream of Wheat ad.
1909

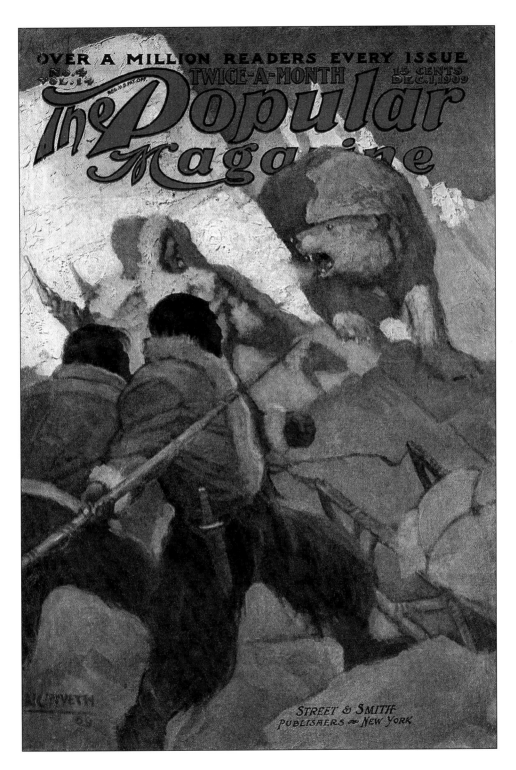

Cover, *The Popular Magazine,*
November 1909

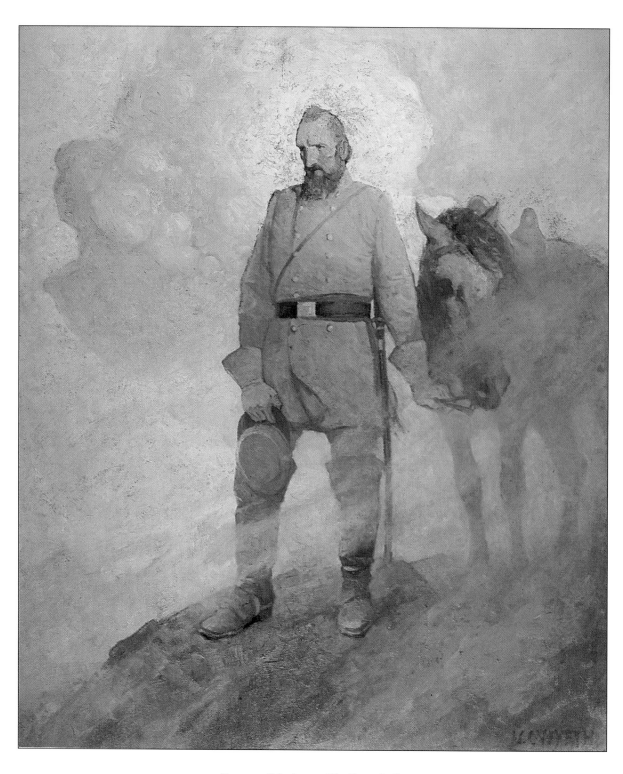

Stonewall Jackson. *The Long Roll,*
Houghton Mifflin Company, Boston and New York, 1911

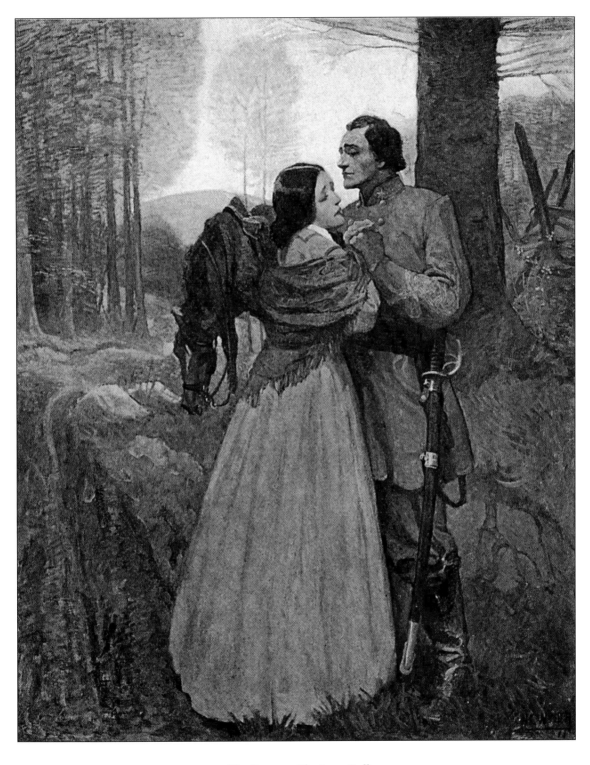

The Lovers. *The Long Roll,*
Houghton Mifflin Company, Boston and New York, 1911

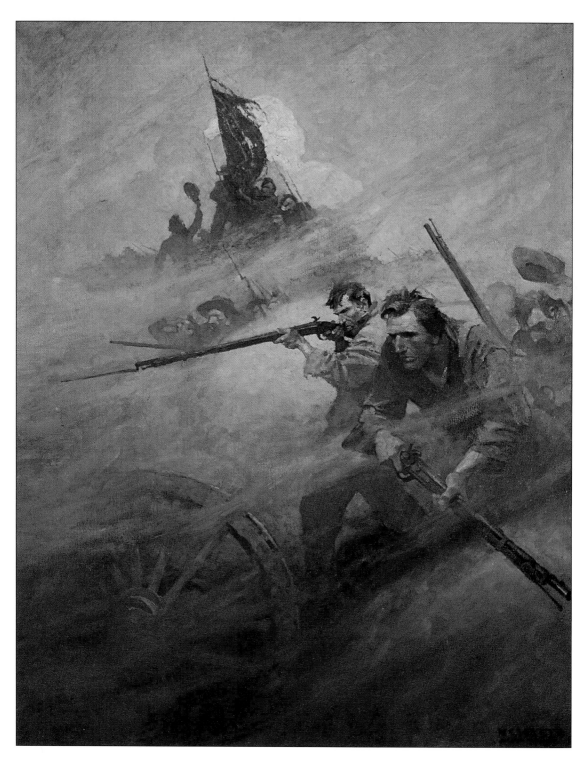

The Battle. *The Long Roll,*
Houghton Mifflin Company, Boston and New York, 1911

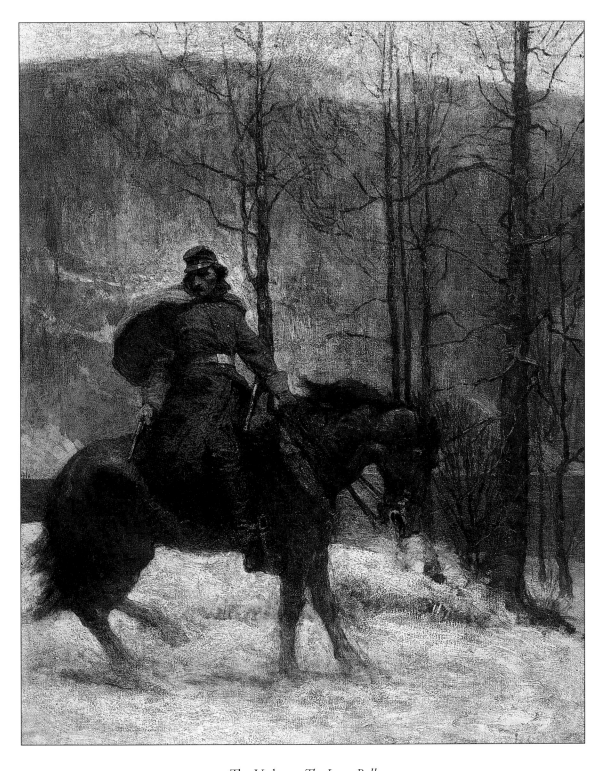

The Vedette. *The Long Roll,*
Houghton Mifflin Company, Boston and New York, 1911

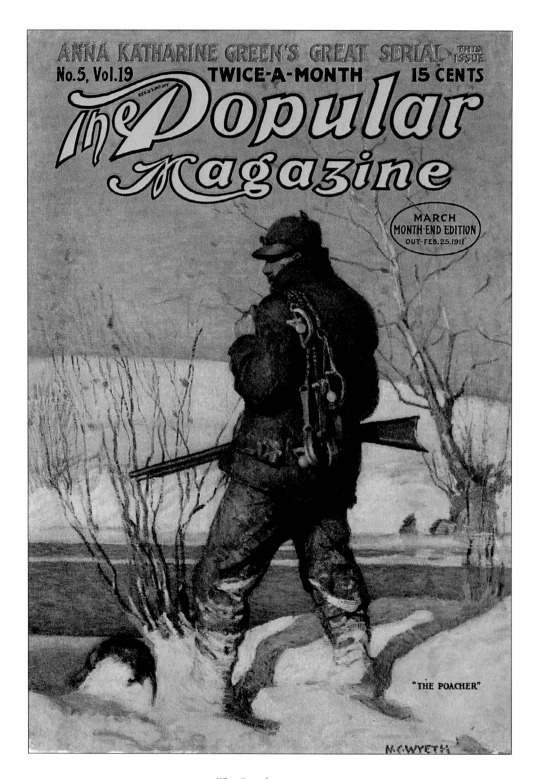

The Poacher, cover,
The Popular Magazine, March 1911

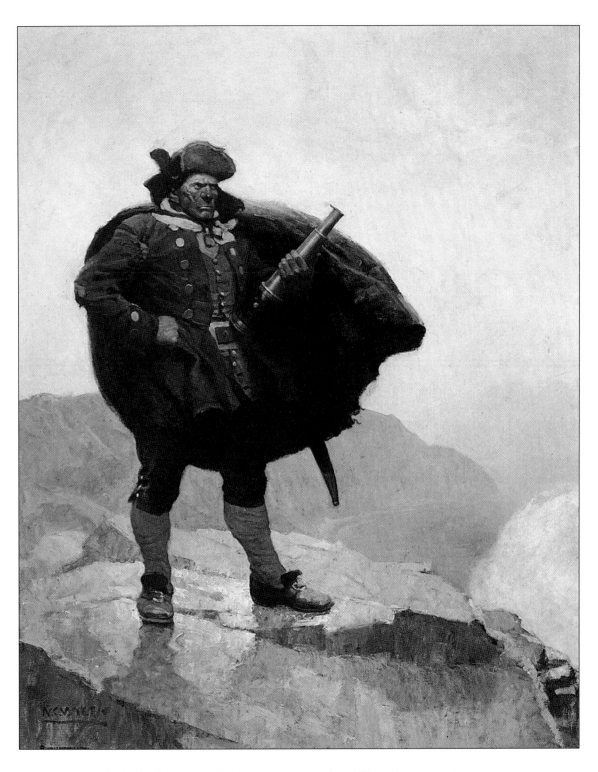

All day he hung round the cove, or upon the cliffs, with a brass telescope.
Treasure Island, Charles Scribner's Sons, New York, 1911

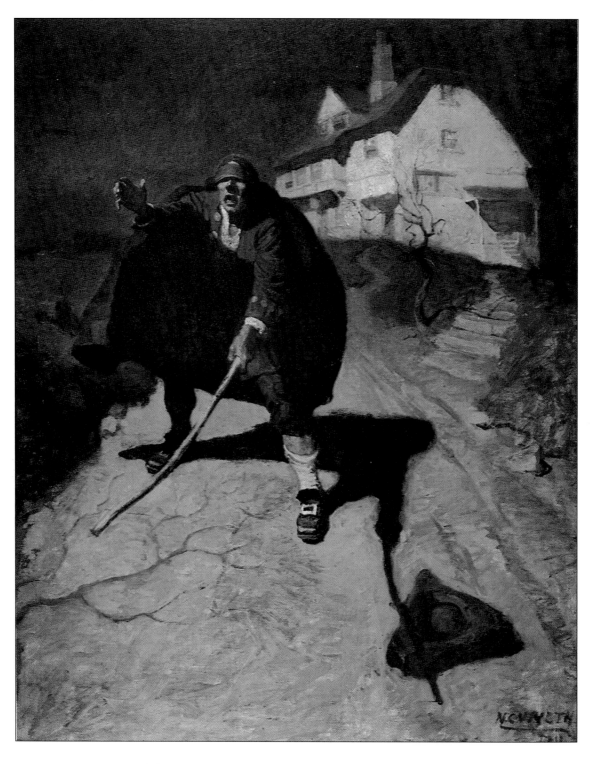

Tapping up and down the road in a frenzy, and groping and calling for his comrades.
Treasure Island, Charles Scribner's Sons, New York, 1911

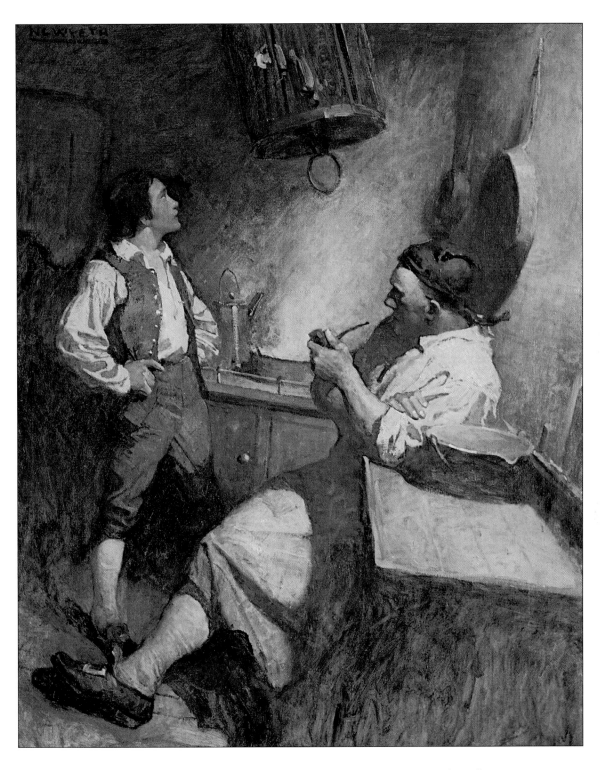

To me he was unweariedly kind; and always glad to see me in the galley.
Treasure Island, Charles Scribner's Sons, New York, 1911

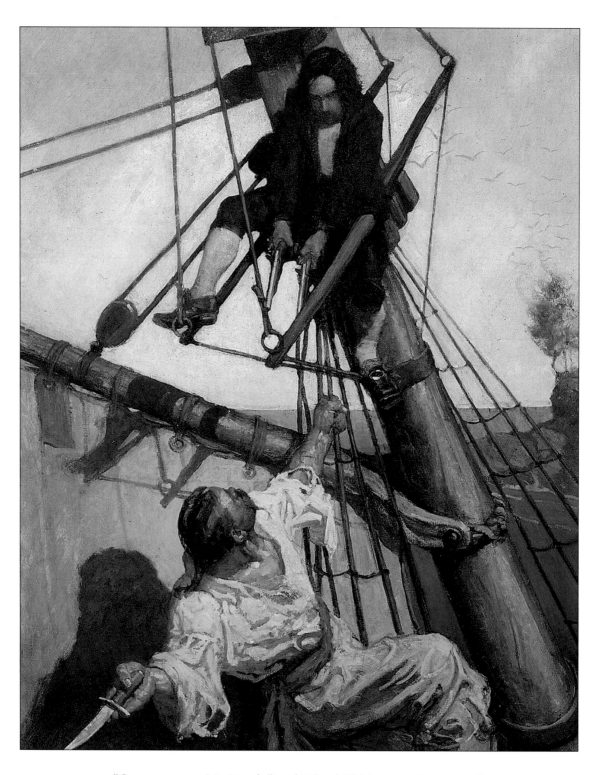

"One more step, Mr. Hands," said I, "and I'll blow your brains out."
Treasure Island, Charles Scribner's Sons, New York, 1911

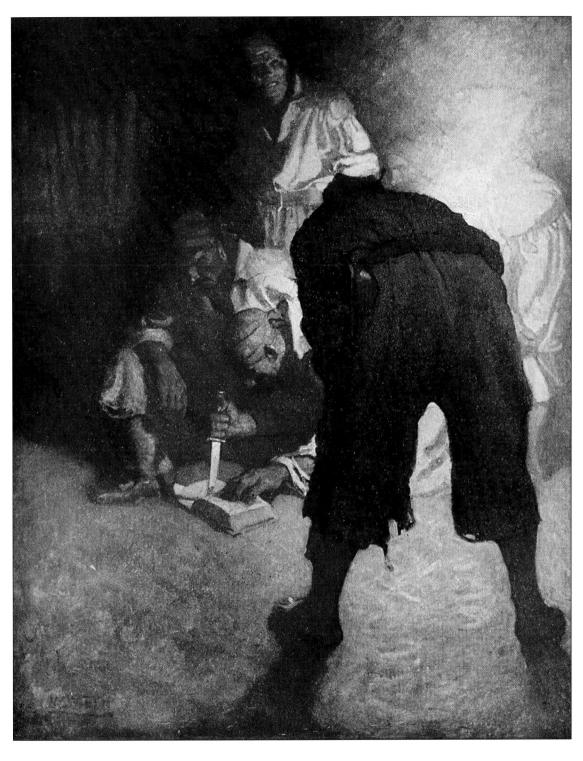

About half way down the slope to the stockade, they were collected in a group.
Treasure Island, Charles Scribner's Sons, New York, 1911

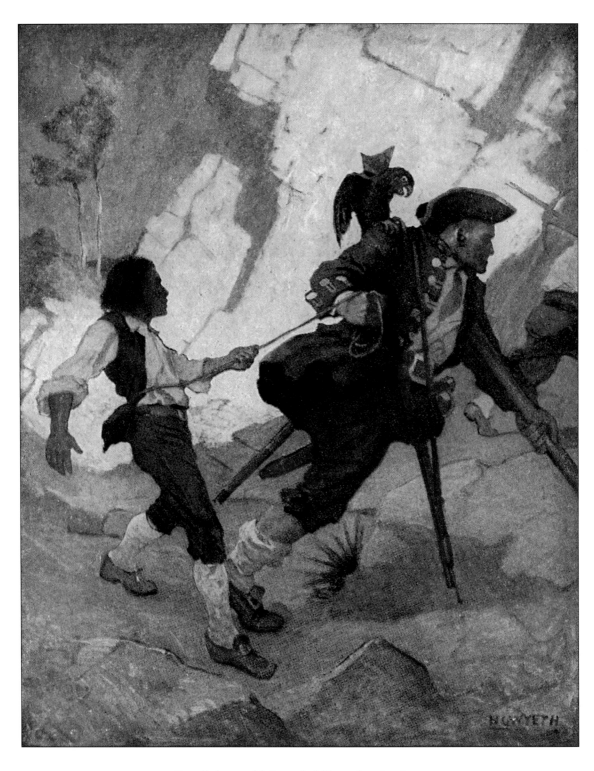

For all the world, I was led like a dancing bear.
Treasure Island, Charles Scribner's Sons, New York, 1911

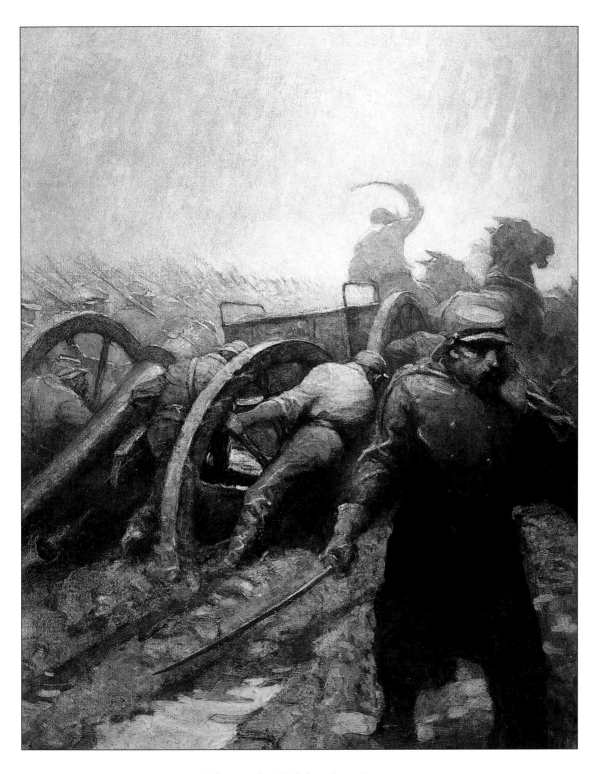

The Road to Vidalia. *Cease Firing,*
Houghton Mifflin Company, Boston and New York, 1912

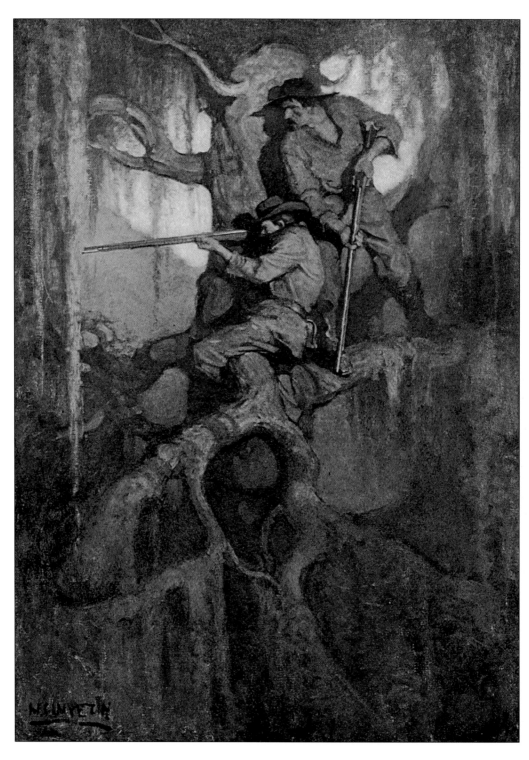

Sharpshooters. *Cease Firing,*
Houghton Mifflin Company, Boston and New York, 1912

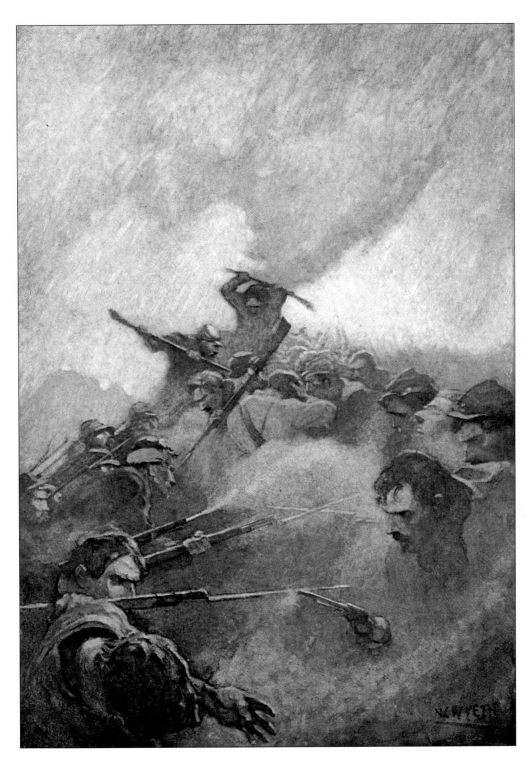

The Bloody Angle. *Cease Firing,*
Houghton Mifflin Company, Boston and New York, 1912

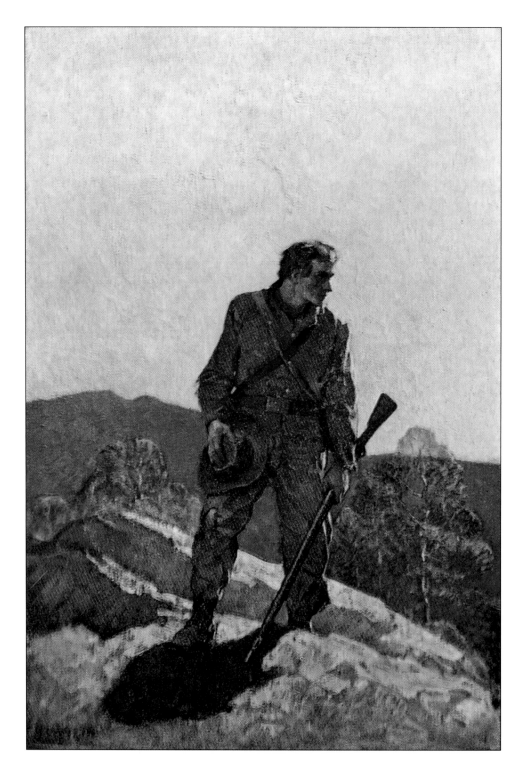

The Scout. *Cease Firing,*
Houghton Mifflin Company, Boston and New York, 1912

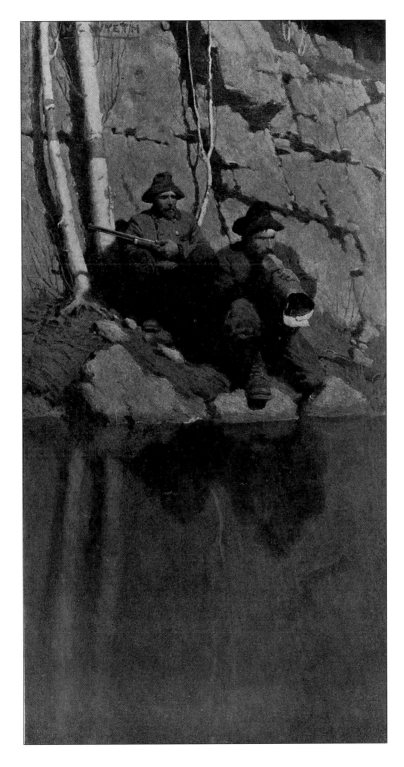

The Moose Hunter. A Moonlit Night.
Scribner's Magazine, October 1912

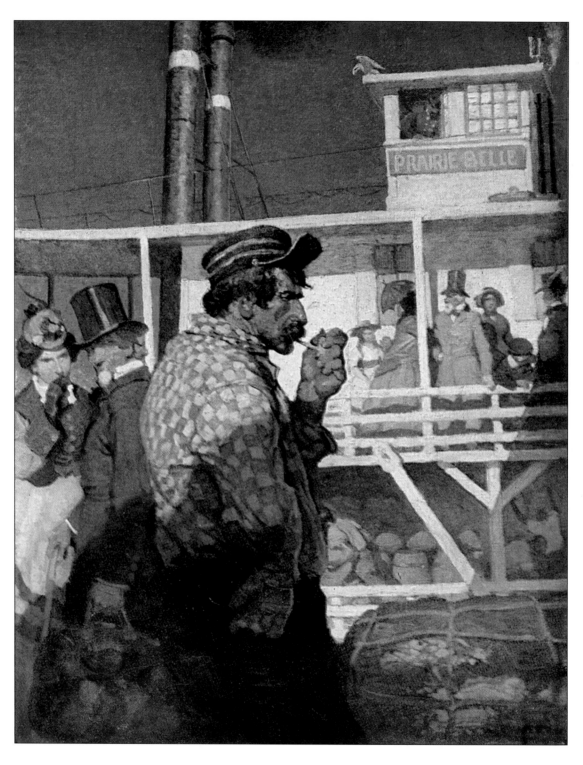

He were n't no saint,—them engineers is all pretty much alike. *The Pike County Ballads,*
Houghton Mifflin Company, Boston and New York, 1912

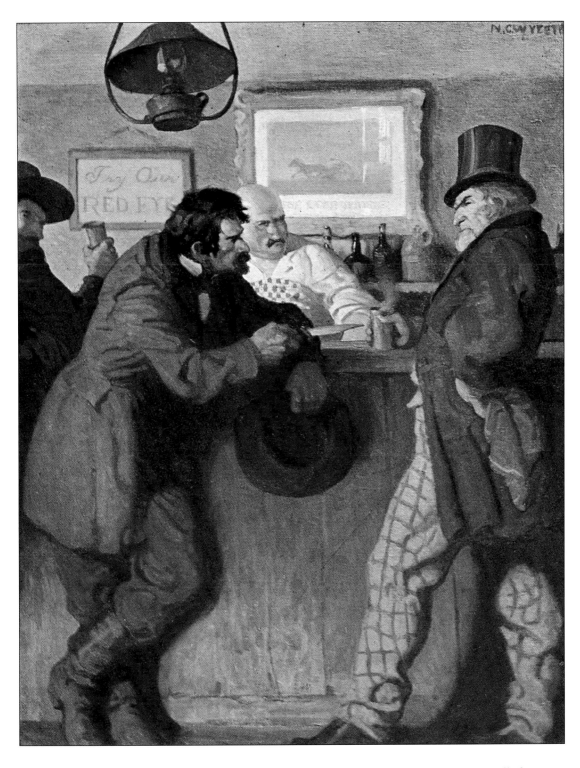

"I ax yer parding, Mister Phinn—Jest drap that whisky-skin." *The Pike County Ballads,*
Houghton Mifflin Company, Boston and New York, 1912

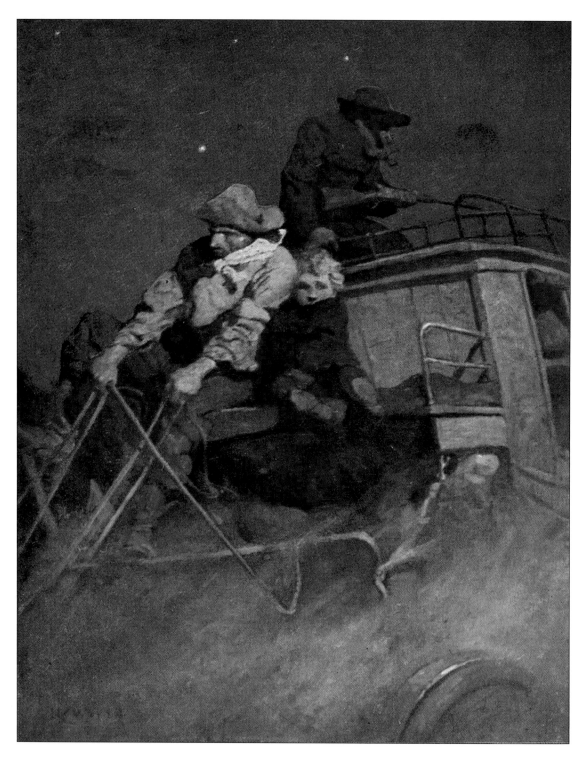

Over hill and holler and ford and creek Jest like the hosses had wings, we tore.
The Pike County Ballads, Houghton Mifflin Company, Boston and New York, 1912

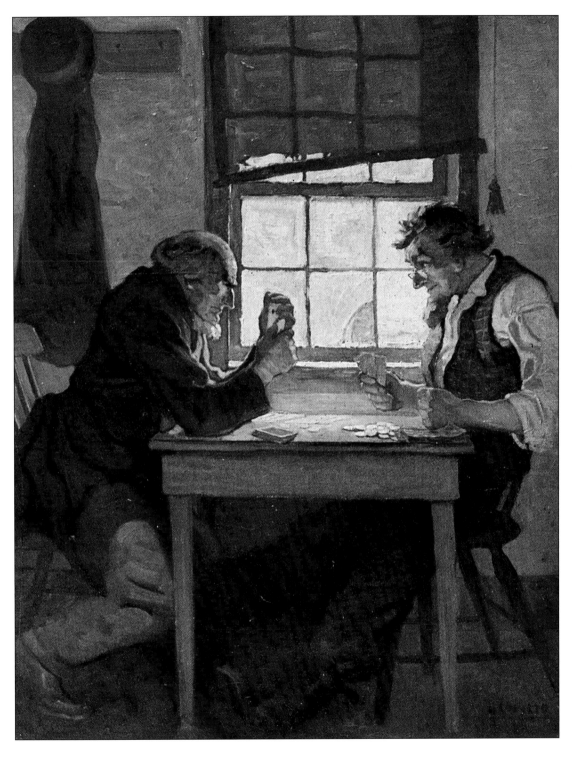

The Deacon and Parson Skeeters in the tail of a game of Draw. *The Pike County Ballads,*
Houghton Mifflin Company, Boston and New York, 1912

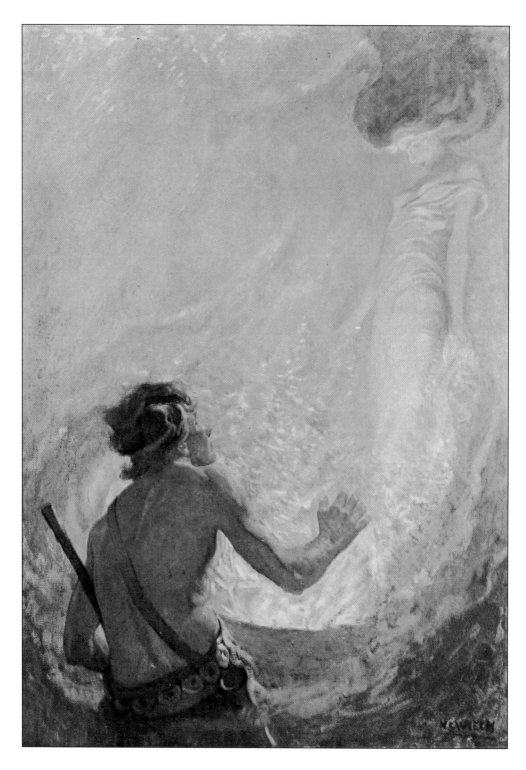

The Golden Maiden. *The Sampo,*
Charles Scribner's Sons, New York, 1912

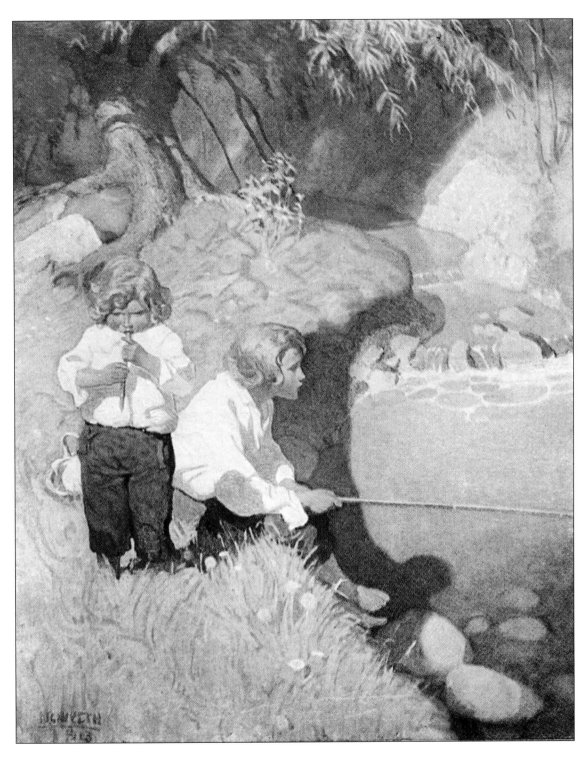

He never caught a thing and he ruined Jon's reputation as a fisherman.
War, The Bobbs-Merrill Company, Indianapolis, 1913

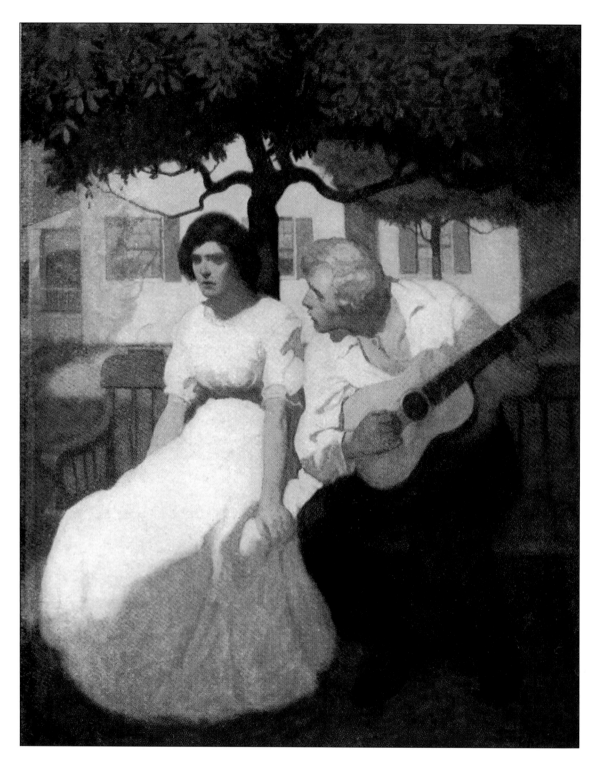

Then he looked in her face, playing softer and softer.
War, The Bobbs-Merrill Company, Indianapolis, 1913

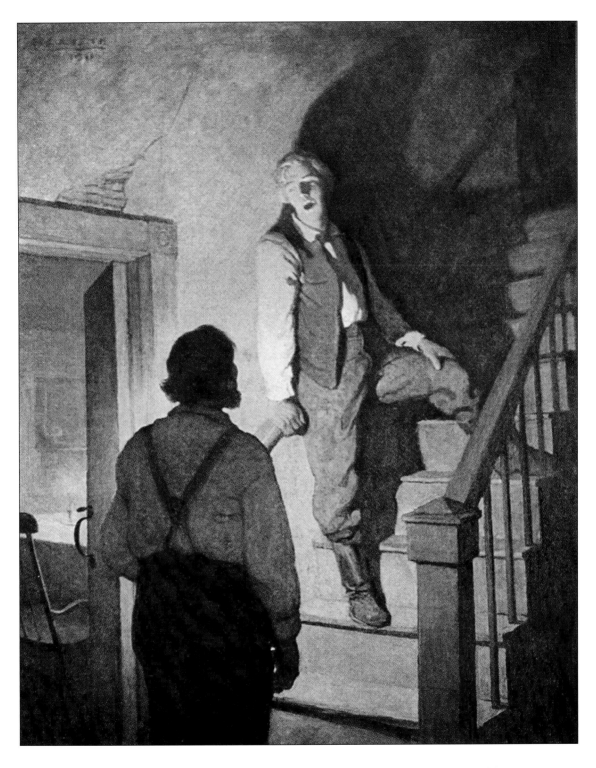

He stopped two or three steps up and sang me a little song—quite like the old Dave.
War, The Bobbs-Merrill Company, Indianapolis, 1913

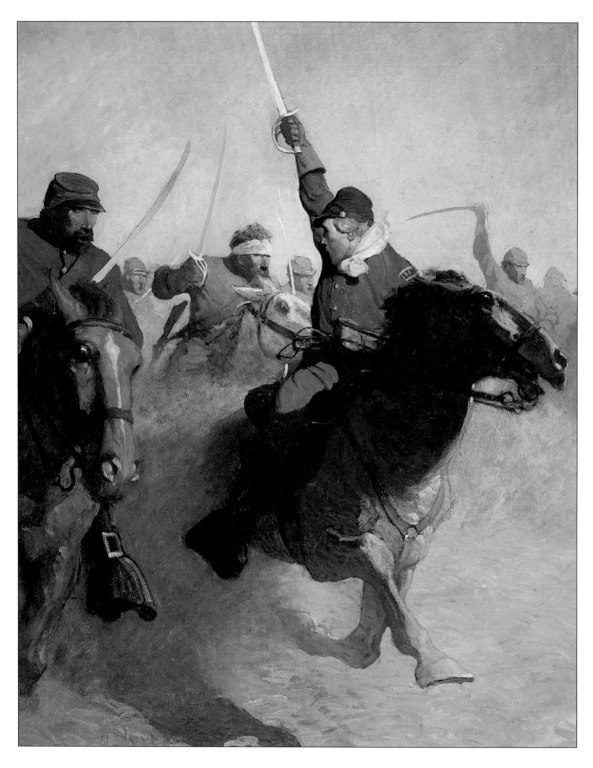

War. *War,*
The Bobbs-Merrill Company, Indianapolis, 1913

46

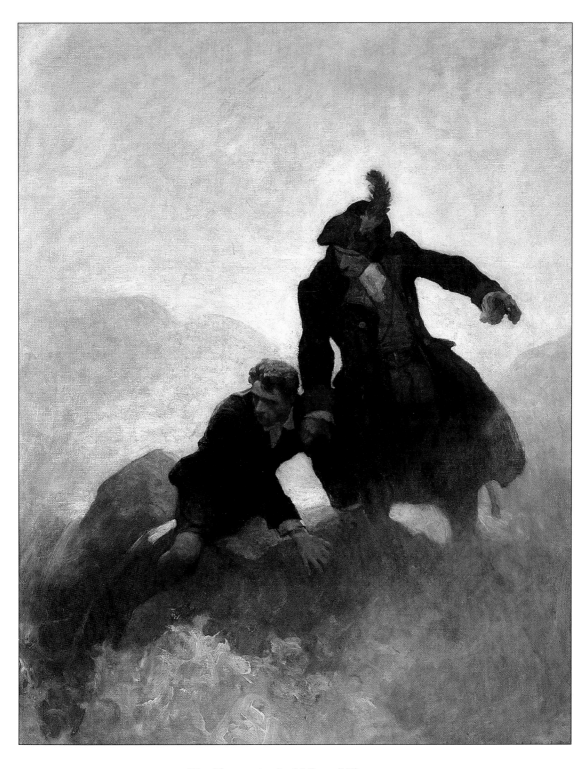

The Torrent in the Valley of Glencoe.
Kidnapped, Charles Scribner's Sons, New York, 1913

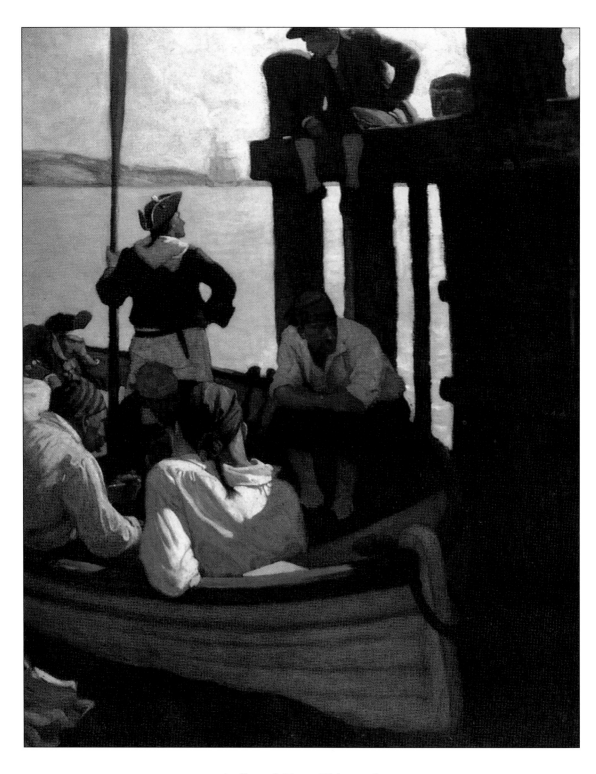

At Queen's Ferry. *Kidnapped,*
Charles Scribner's Sons, New York, 1913

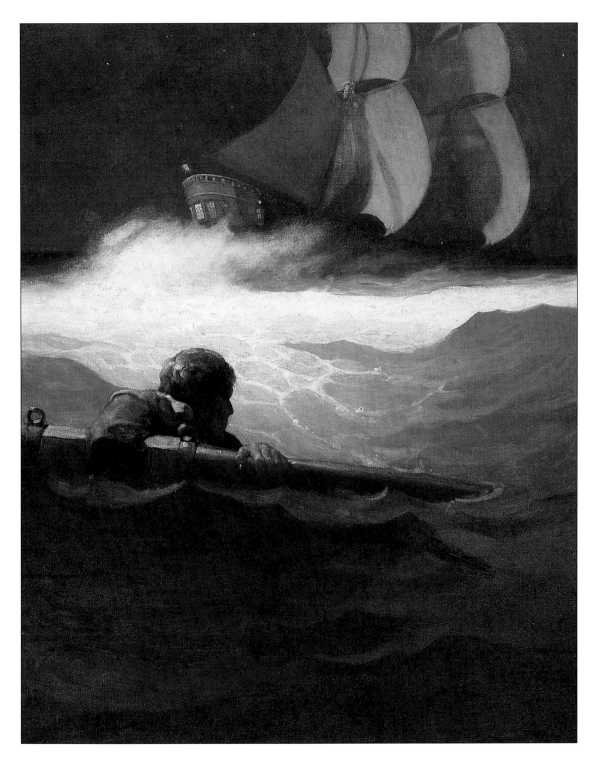

The Wreck of the "Covenant." *Kidnapped,*
Charles Scribner's Sons, New York, 1913

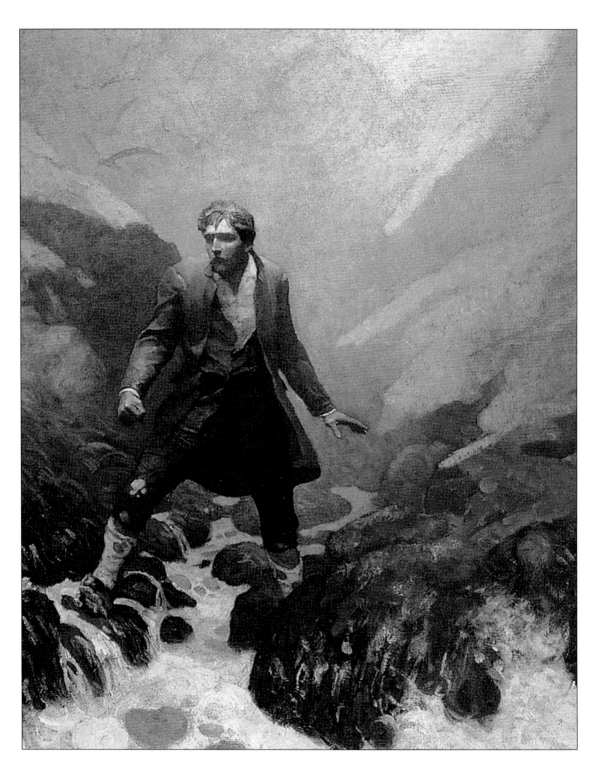

On the Island of Earraid. *Kidnapped,*
Charles Scribner's Sons, New York, 1913

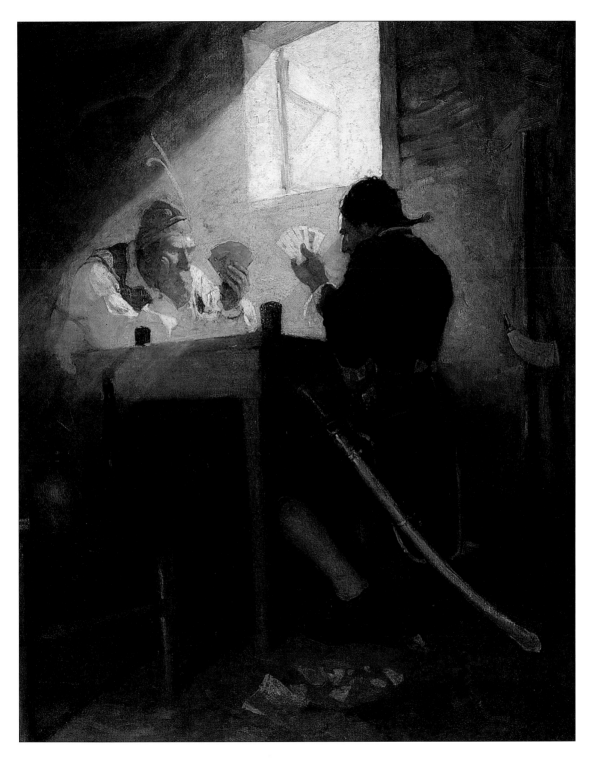

At the cards in Cluny's Cage. *Kidnapped,*
Charles Scribner's Sons, New York, 1913

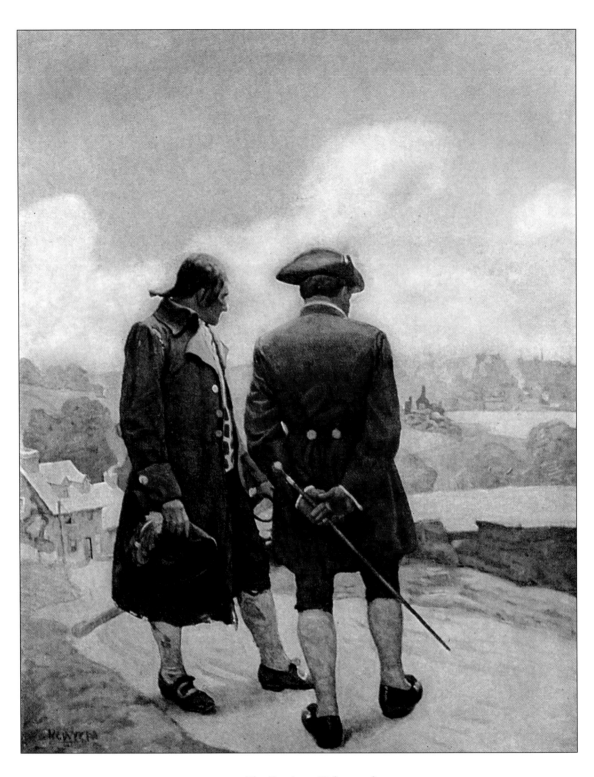

The Parting. *Kidnapped,*
Charles Scribner's Sons, New York, 1913

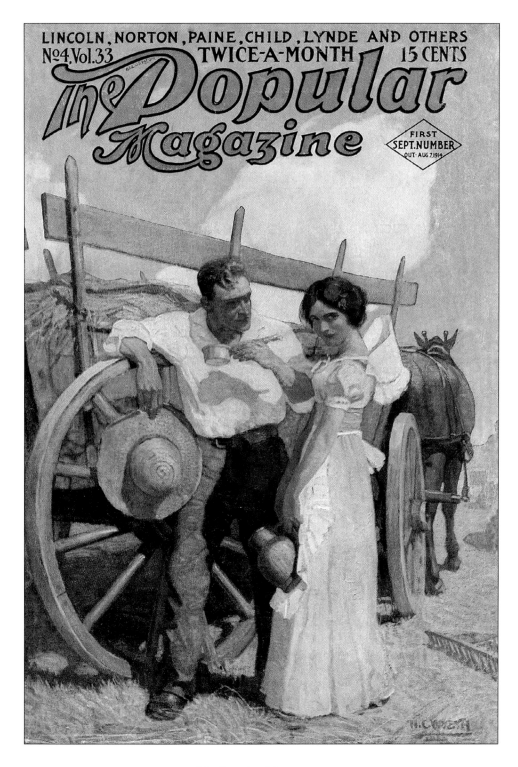

The Popular Magazine, cover,
September 1914

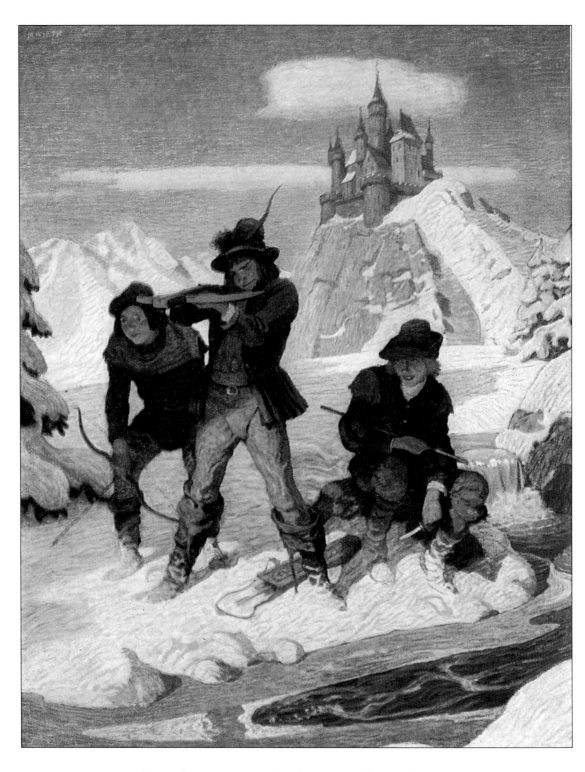

Eseldorf was a paradise for us boys. *The Mysterious Stranger,*
Charles Scribner's Sons, New York, 1916

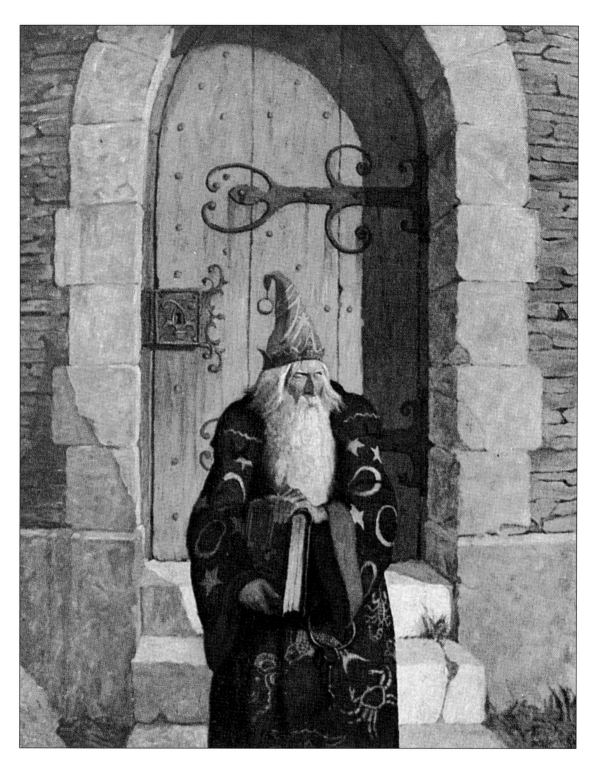

The Astrologer. *The Mysterious Stranger,*
Charles Scribner's Sons, New York, 1916

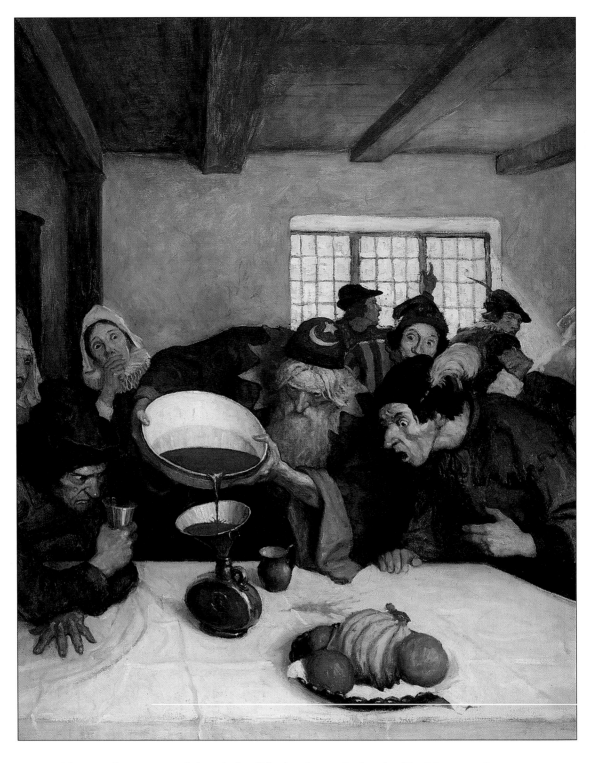

The Astrologer emptied the whole of the bowl into the bottle. *The Mysterious Stranger,*
Charles Scribner's Sons, New York, 1916

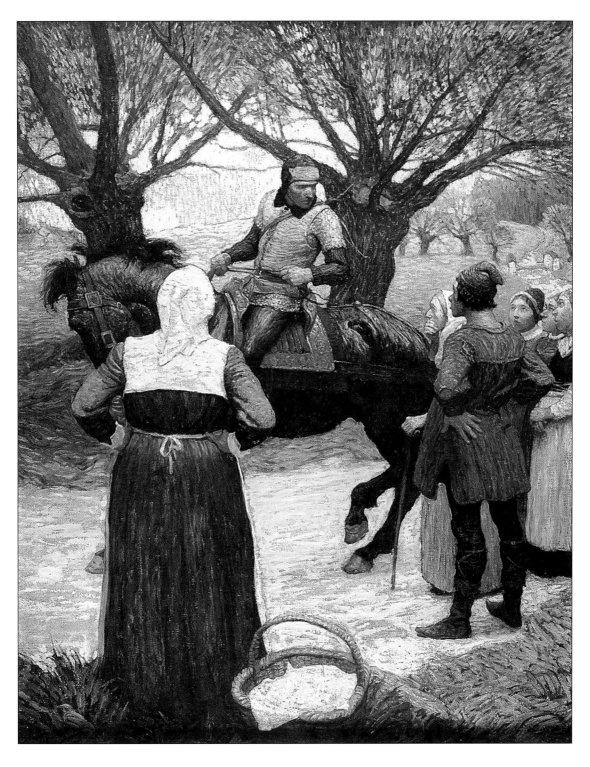

"They cannot better die than for their natural lord," said Dick. *The Black Arrow,*
Charles Scribner's Sons, New York, 1916

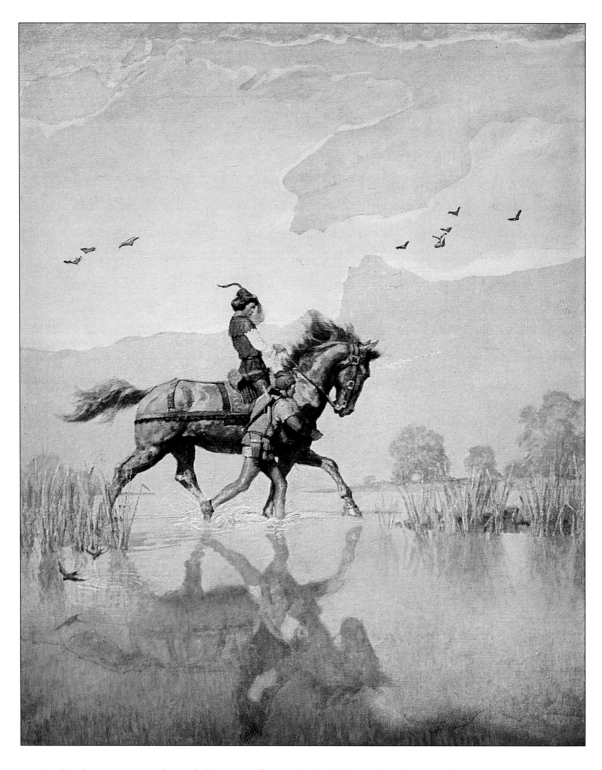

So the change was made, and they went forward as briskly as they durst on the unseen causeway.
The Black Arrow, Charles Scribner's Sons, New York, 1916

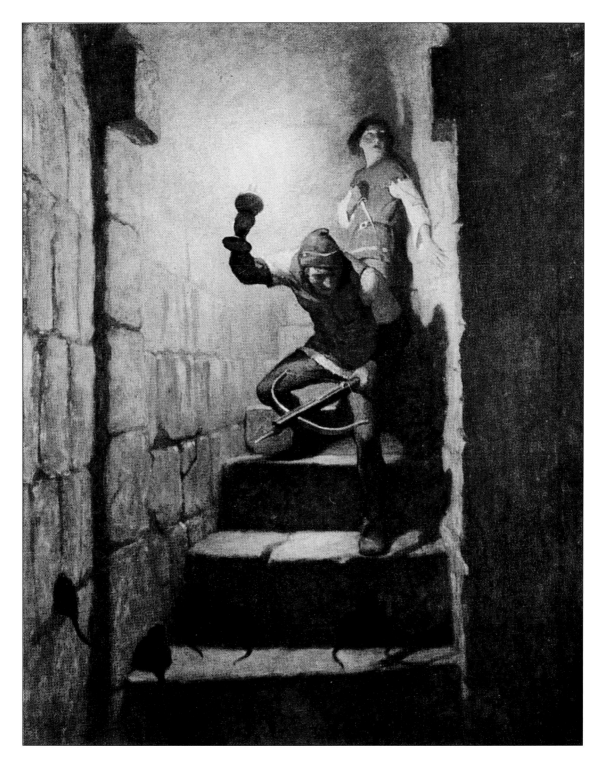

"We must be in the dungeons," Dick remarked. *The Black Arrow,*
Charles Scribner's Sons, New York, 1916

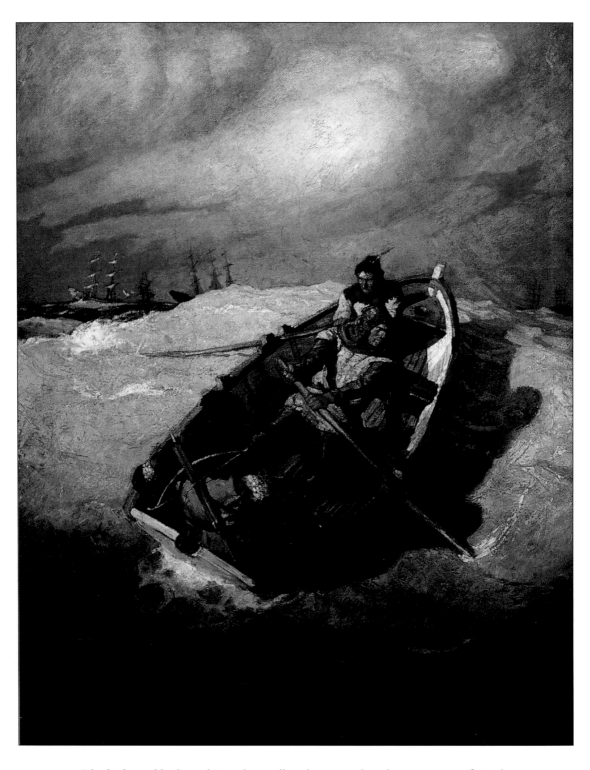

The little cockle dipped into the swell and staggered under every gust of wind.
The Black Arrow, Charles Scribner's Sons, New York, 1916

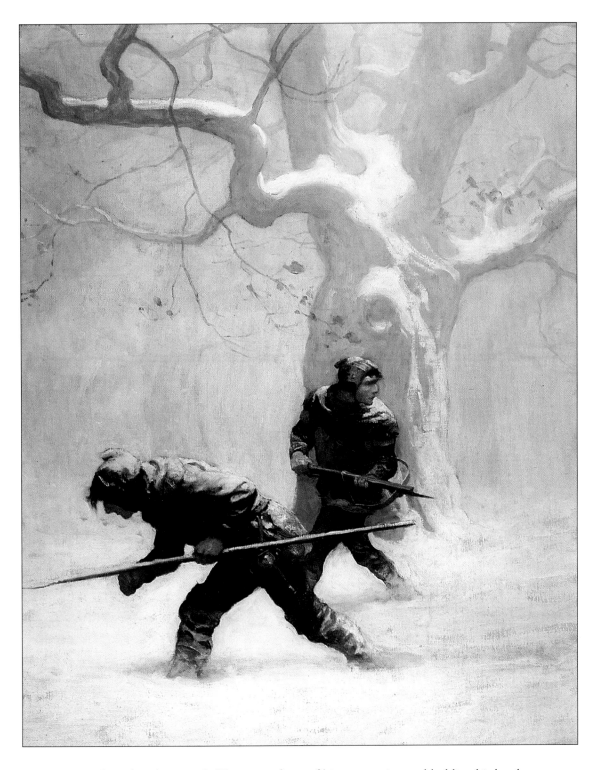

And Lawless, keeping half a step in front of his companion and holding his head
forward like a hunting dog upon the scent, . . . studied out their path.
The Black Arrow, Charles Scribner's Sons, New York, 1916

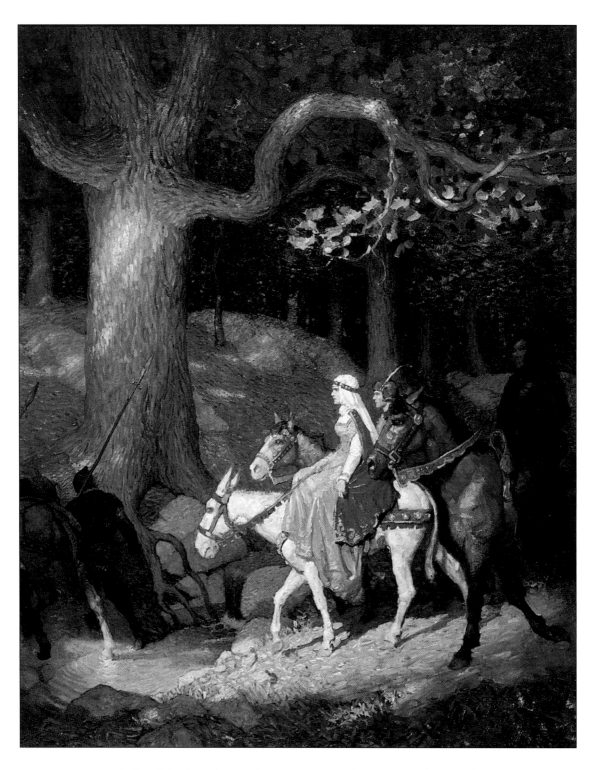

Robin Hood and his mother go to Nottingham Fair. *Robin Hood,*
Charles Scribner's Sons, New York, 1917

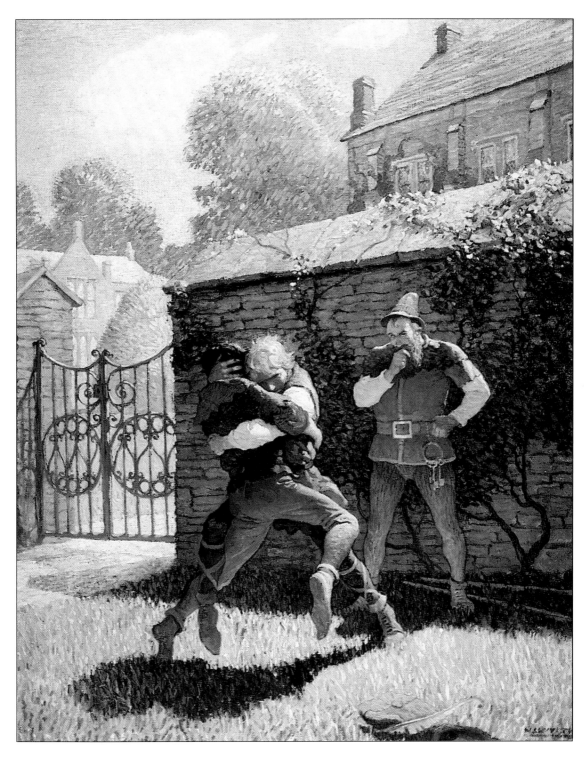

Robin Hood wrestles Will Stuteley at Gamewell. *Robin Hood,*
Charles Scribner's Sons, New York, 1917

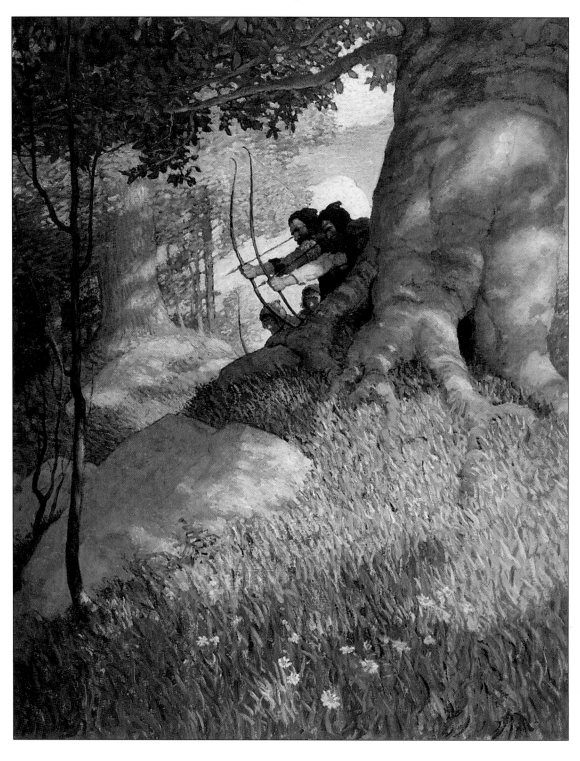

Robin Hood and his companions lend aid to Will o'th' Green from Ambush.
Robin Hood, Charles Scribner's Sons, New York, 1917

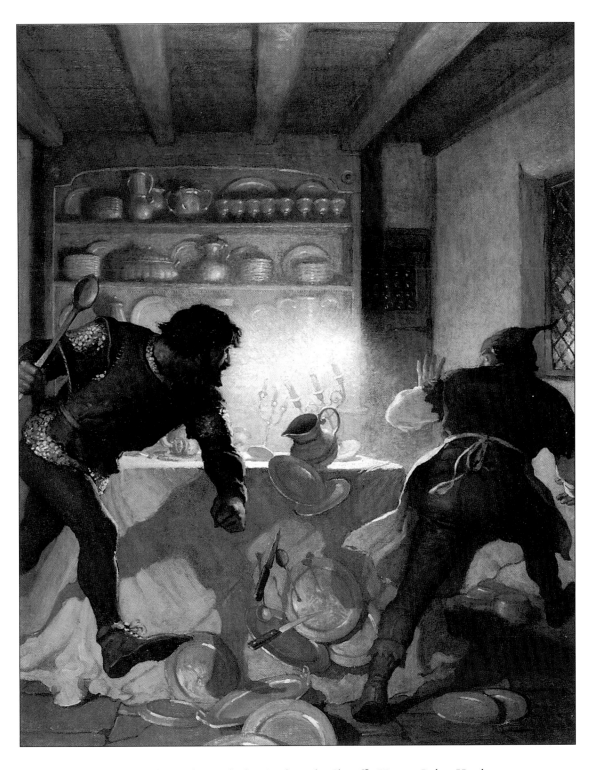

Little John Fights with the Cook in the Sheriff's House. *Robin Hood,*
Charles Scribner's Sons, New York, 1917

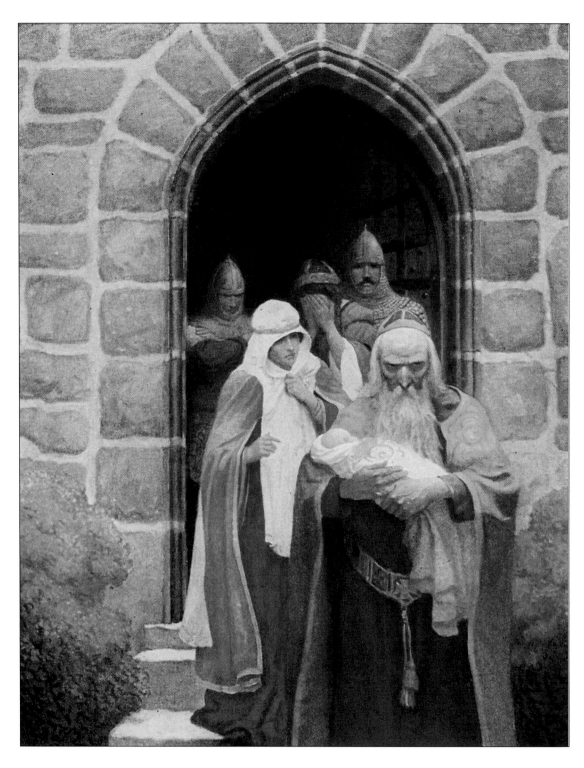

So the child was delivered unto Merlin, and so he bare it forth.
The Boy's King Arthur, Charles Scribner's Sons, New York, 1917

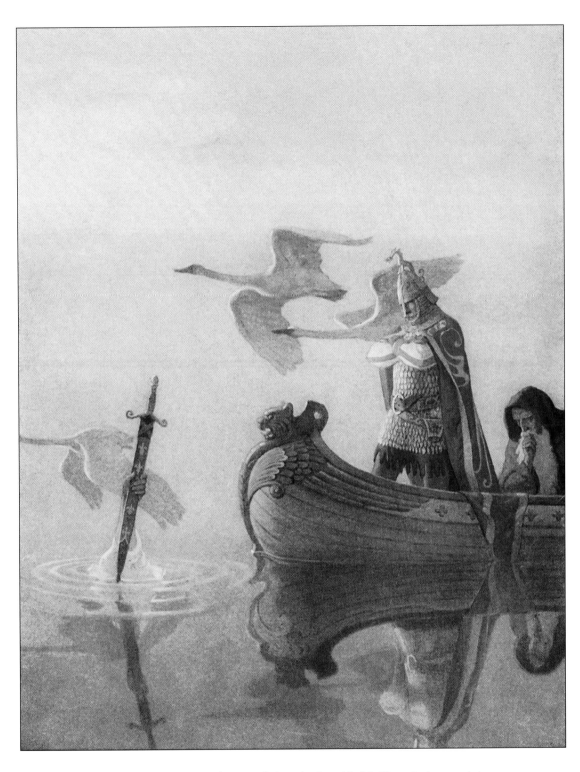

And when they came to the sword that the hand held, King Arthur took it up.
The Boy's King Arthur, Charles Scribner's Sons, New York, 1917

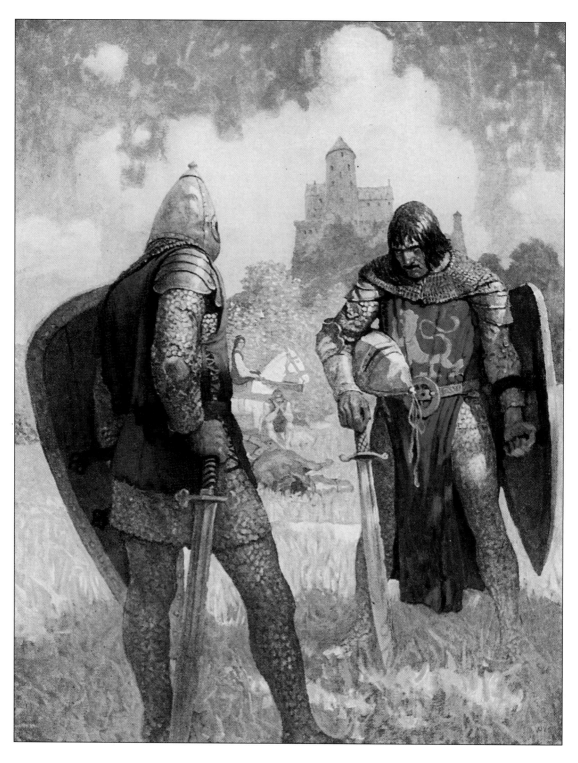

"I am Sir Launclot du Lake, King Ban's son of Benwick, and knight of the Round Table."
The Boy's King Arthur, Charles Scribner's Sons, New York, 1917

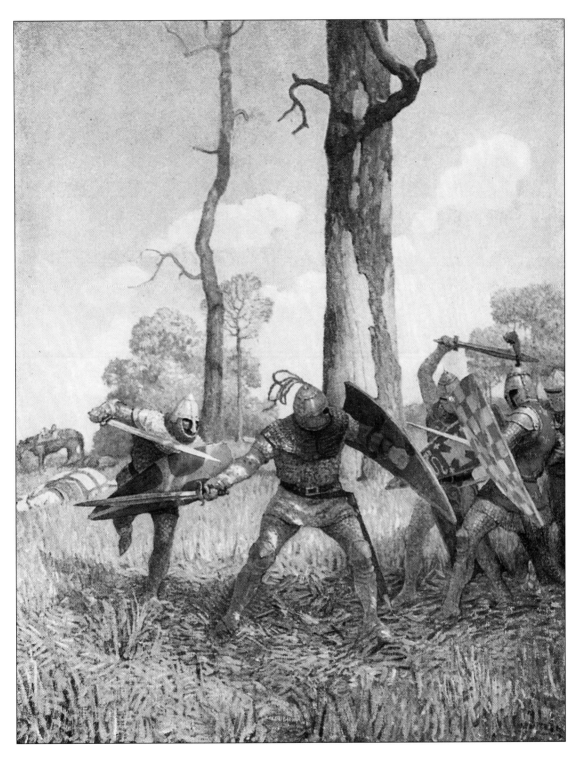

"They fought with him on foot more than three hours, both before him and behind him."
The Boy's King Arthur, Charles Scribner's Sons, New York, 1917

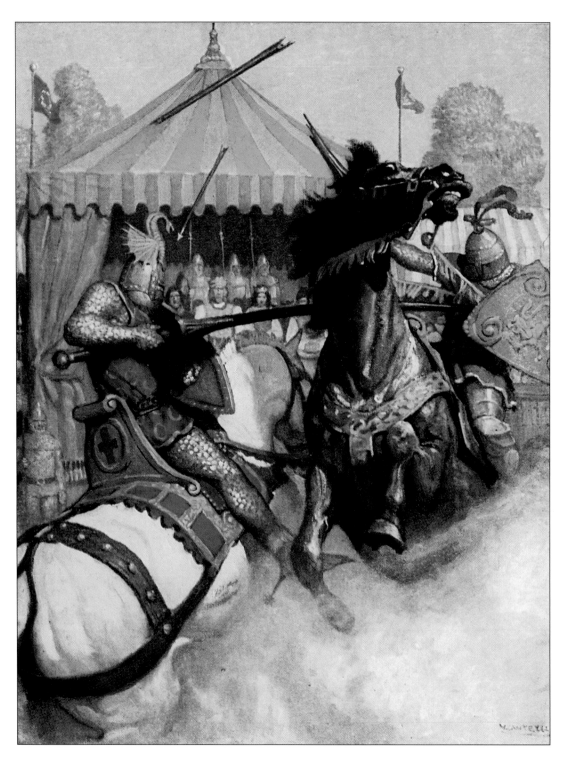

Sir Mador's spear brake all to pieces, but the other's spear held.
The Boy's King Arthur, Charles Scribner's Sons, New York, 1917

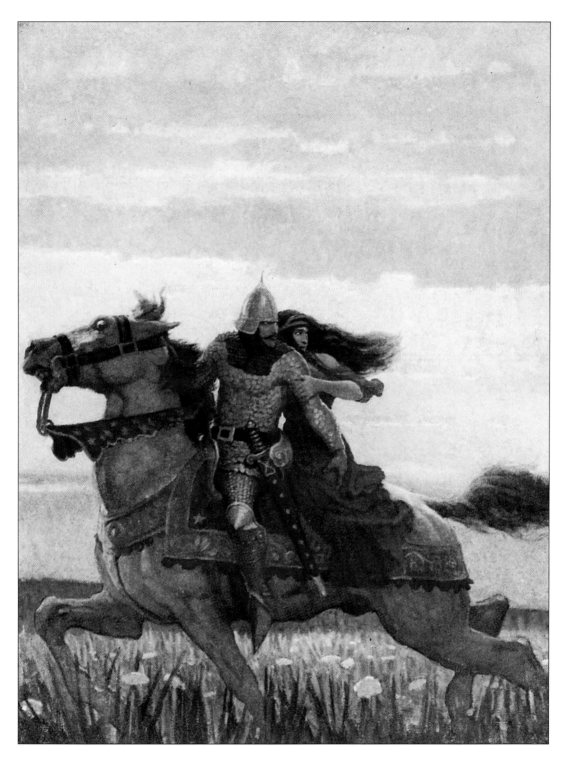

He rode his way with the queen unto Joyous Gard.
The Boy's King Arthur, Charles Scribner's Sons, New York, 1917

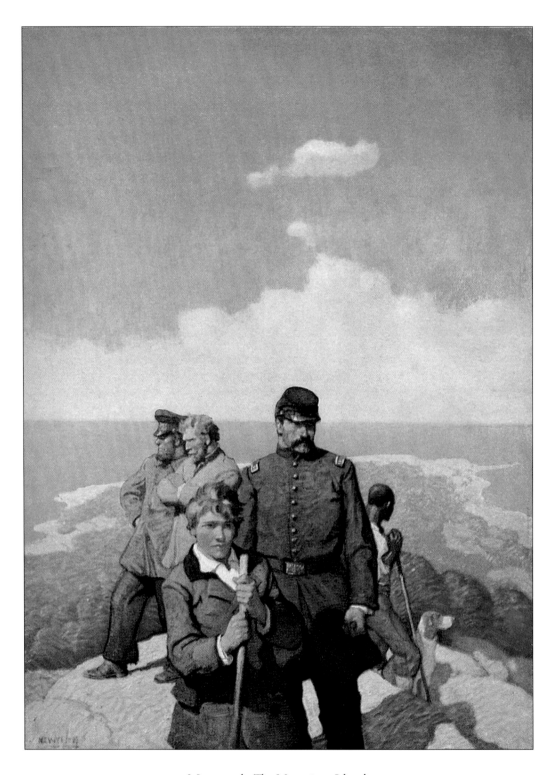

Marooned. *The Mysterious Island,*
Charles Scribner's Sons, New York, 1918

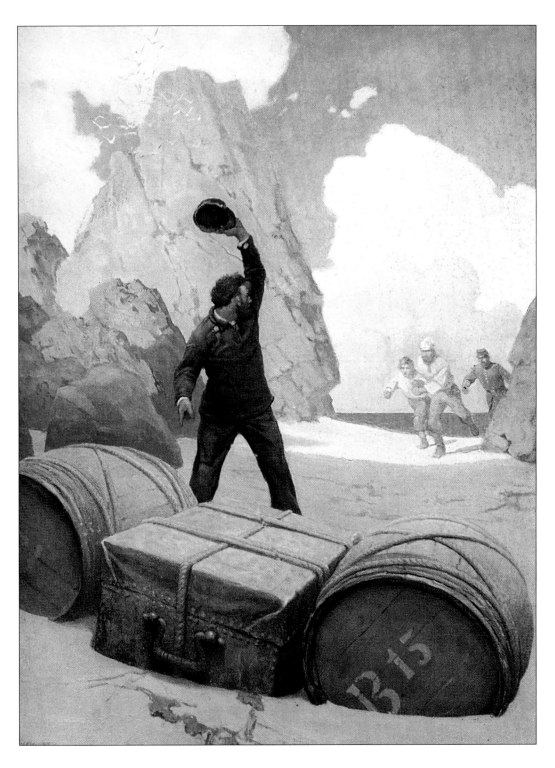

The discovery of the chest. *The Mysterious Island,*
Charles Scribner's Sons, New York, 1918

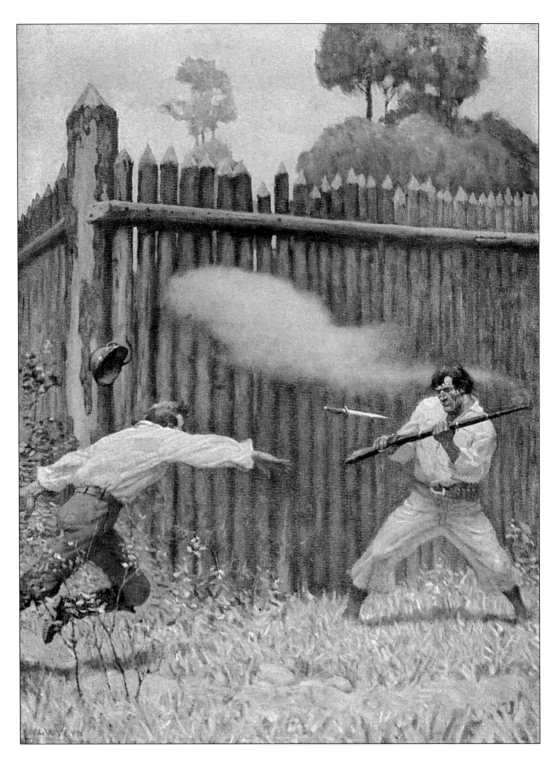

Captain Harding slays a convict. *The Mysterious Island,*
Charles Scribner's Sons, New York, 1918

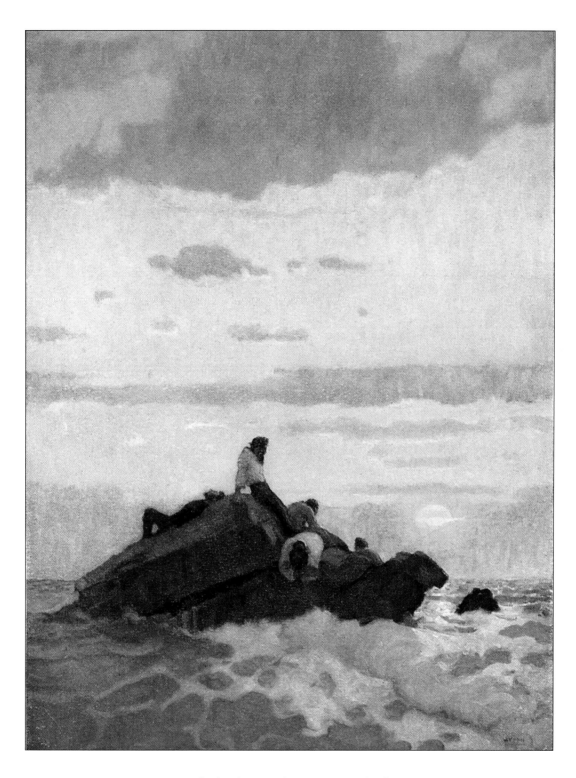

The last hope. *The Mysterious Island,*
Charles Scribner's Sons, New York, 1918

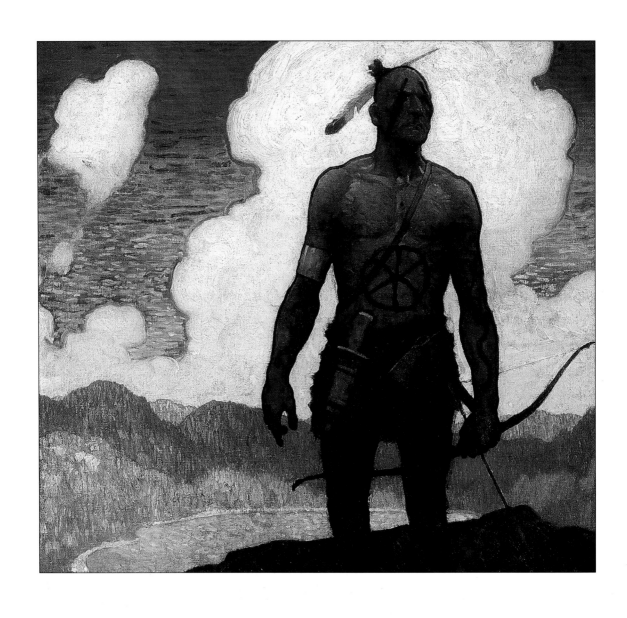

Cover plate, *The Last of the Mohicans,*
Charles Scribner's Sons, New York, 1919

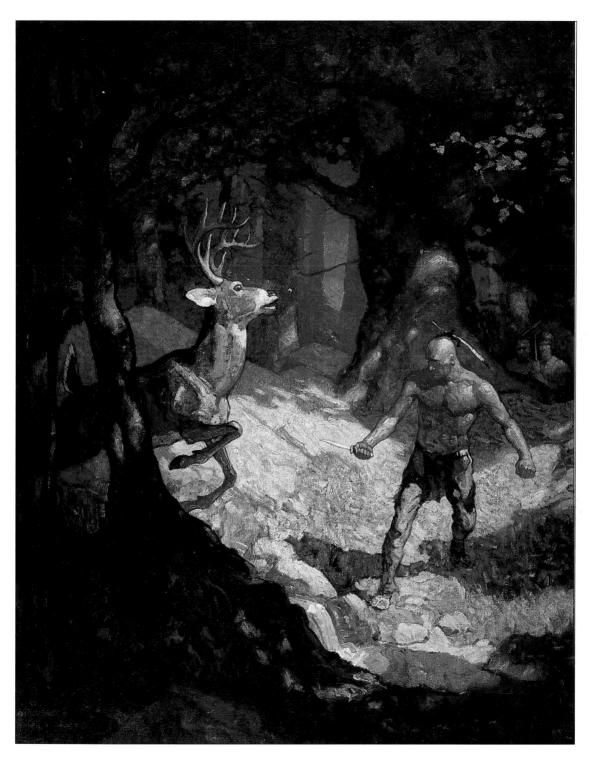

Uncas slays a deer. *The Last of the Mohicans,*
Charles Scribner's Sons, New York, 1919

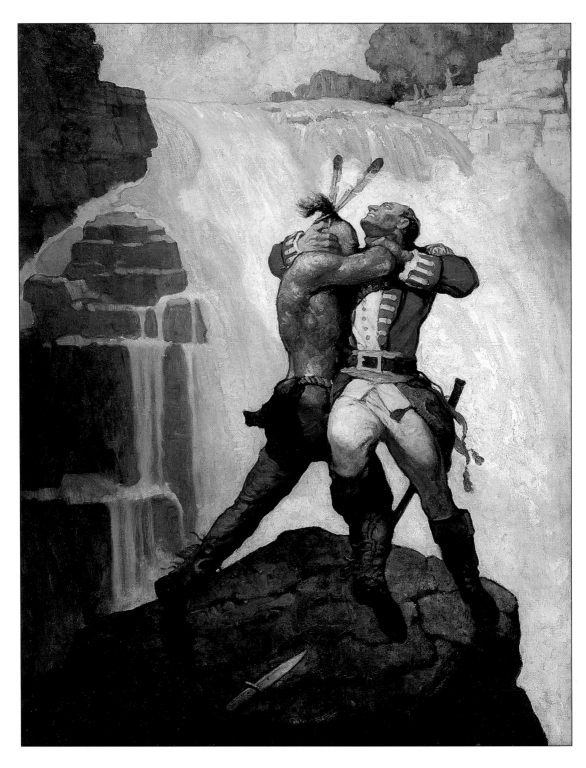

The Battle at Glens Falls. *The Last of the Mohicans,*
Charles Scribner's Sons, New York, 1919

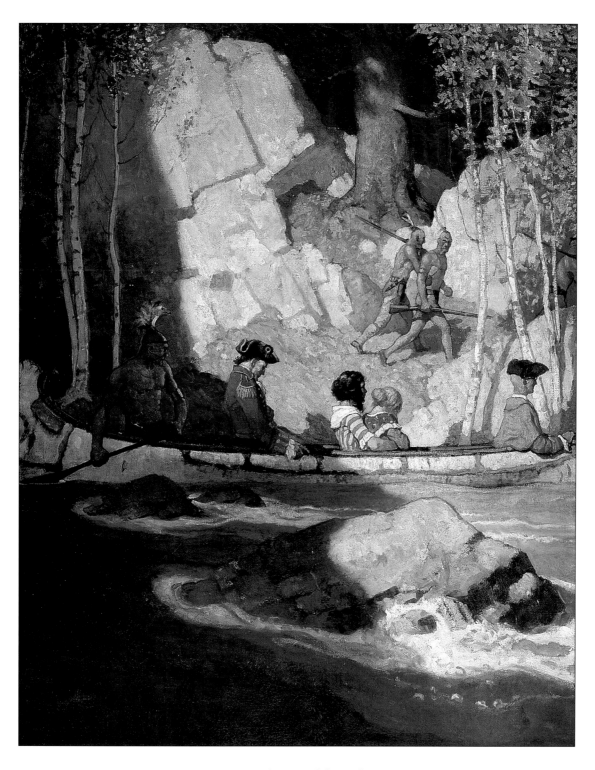

Captives. *The Last of the Mohicans,*
Charles Scribner's Sons, New York, 1919

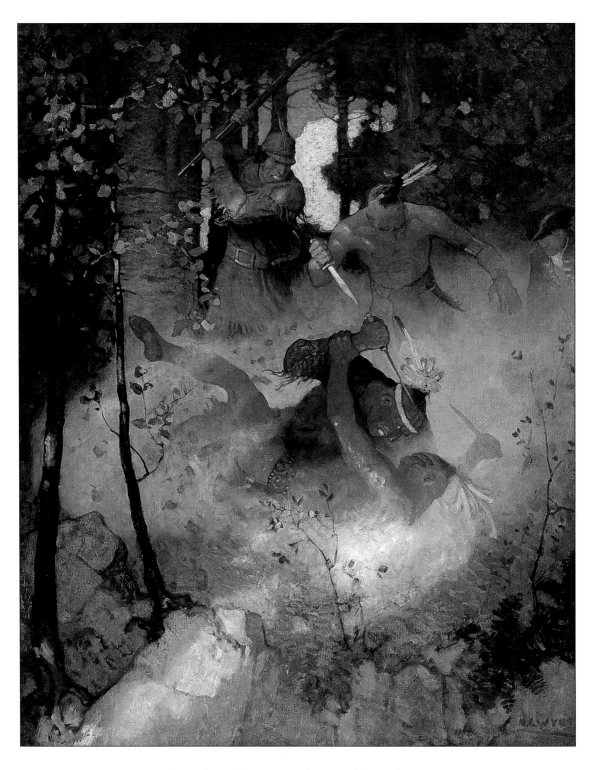

The Fight in the Forest. *The Last of the Mohicans,*
Charles Scribner's Sons, New York, 1919

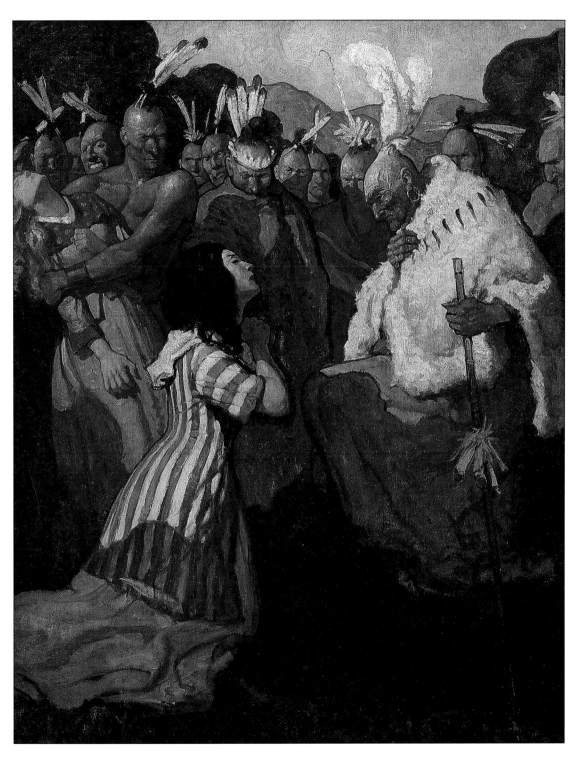

The Supplicant. *The Last of the Mohicans,*
Charles Scribner's Sons, New York, 1919

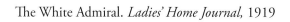

The White Admiral. *Ladies' Home Journal,* 1919

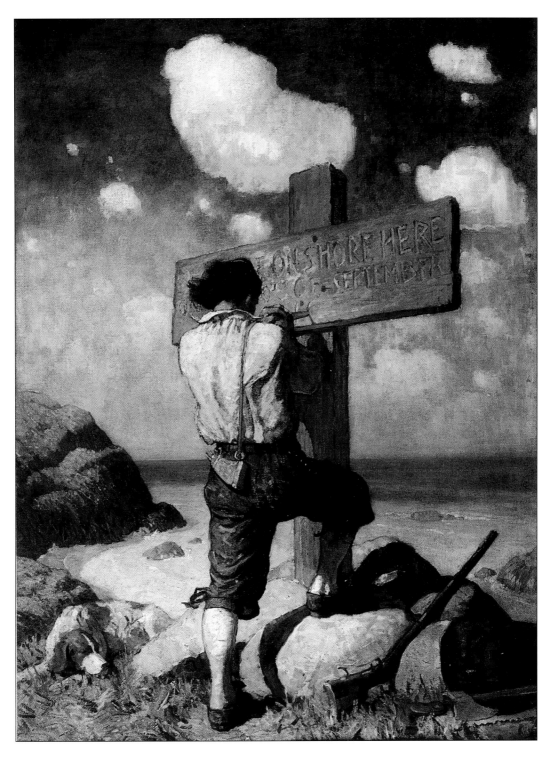

—and making it into a great cross, I set it up on the shore where I first landed.
Robinson Crusoe, Charles Scribner's Sons, New York, 1920

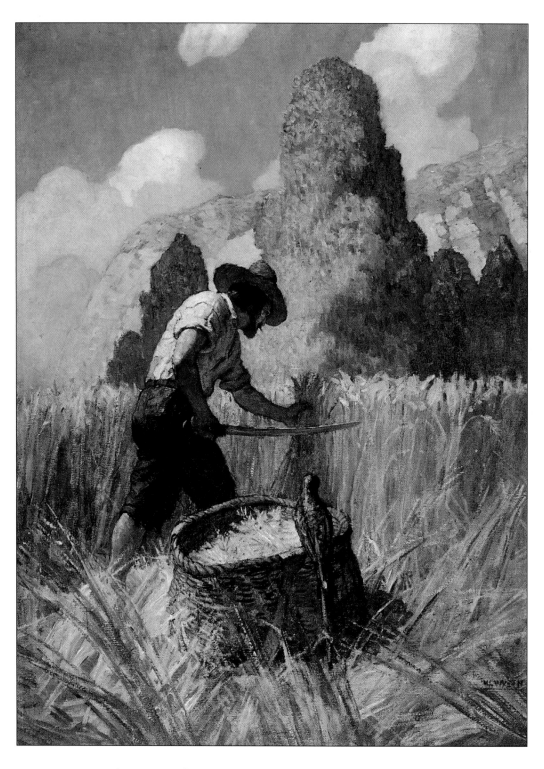

I reaped it my way, for I cut nothing off but the ears, and carried it away
in a great basket which I had made. *Robinson Crusoe,*
Charles Scribner's Sons, New York, 1920

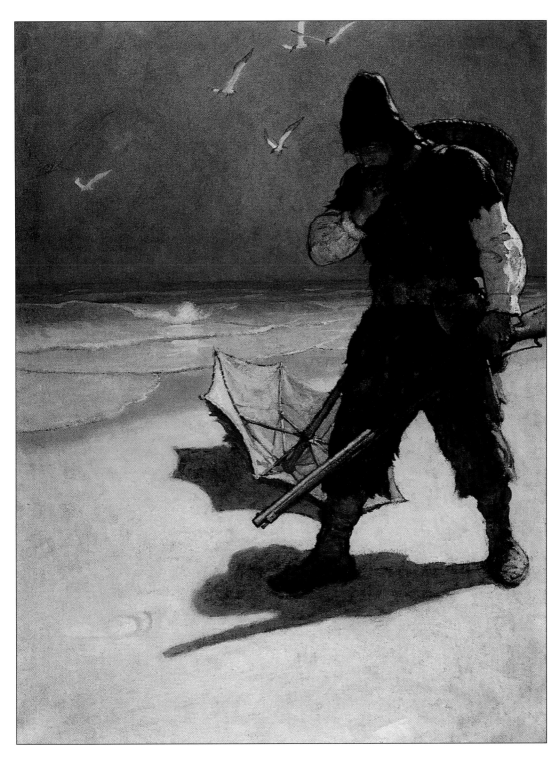

I stood like one thunderstruck, or as if I had seen an apparition.
Robinson Crusoe, Charles Scribner's Sons, New York, 1920

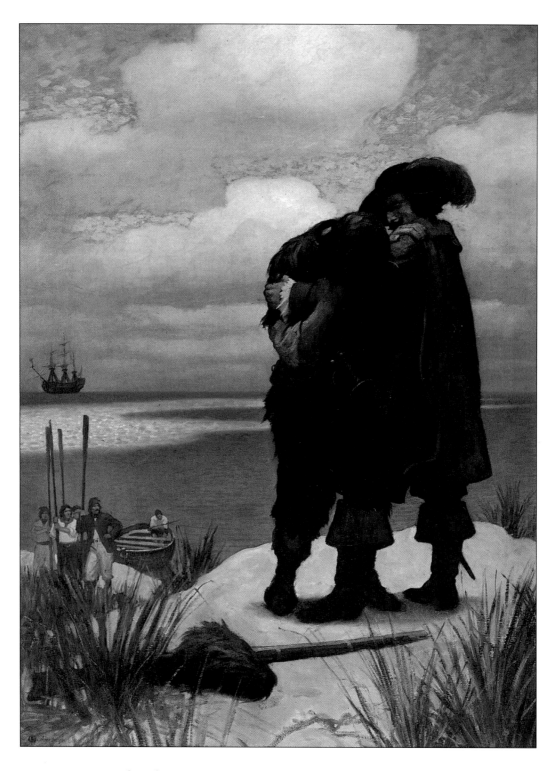

At first, for some time I was not able to answer him one word;
but as he had taken me in his arms, I held fast by him, or I should have fallen to the ground.
Robinson Crusoe, Charles Scribner's Sons, New York, 1920

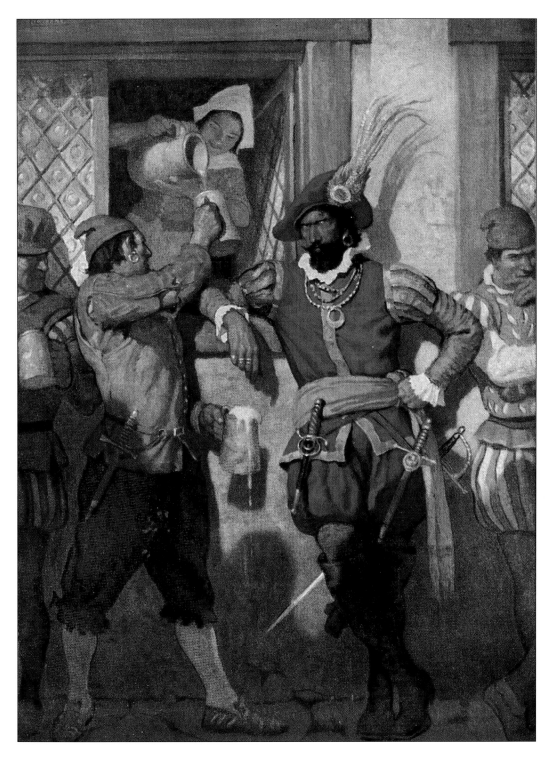

John Oxenham. *Westward Ho!,*
Charles Scribner's Sons, New York, 1920

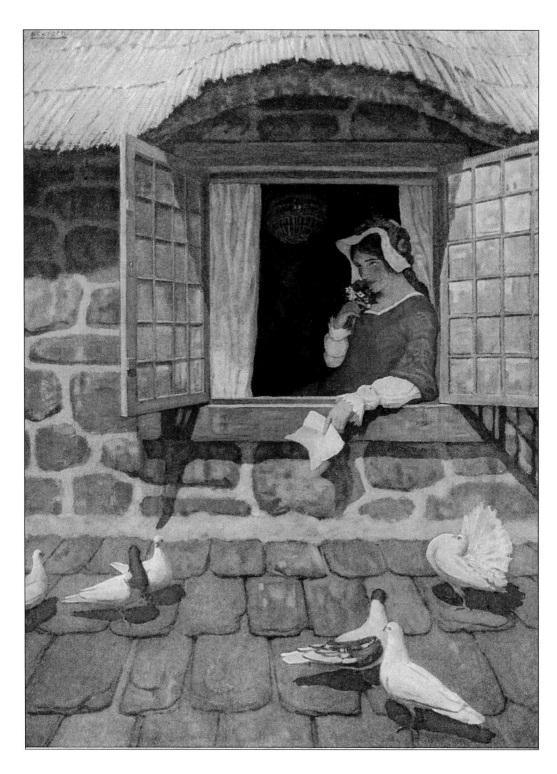

Rose of Torridge. *Westward Ho!*,
Charles Scribner's Sons, New York, 1920

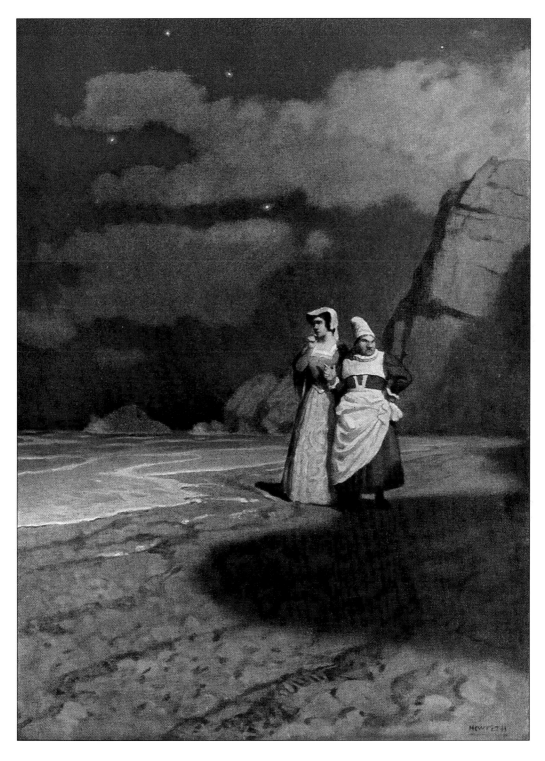

Rose Salterne and the White Witch. *Westward Ho!,*
Charles Scribner's Sons, New York, 1920

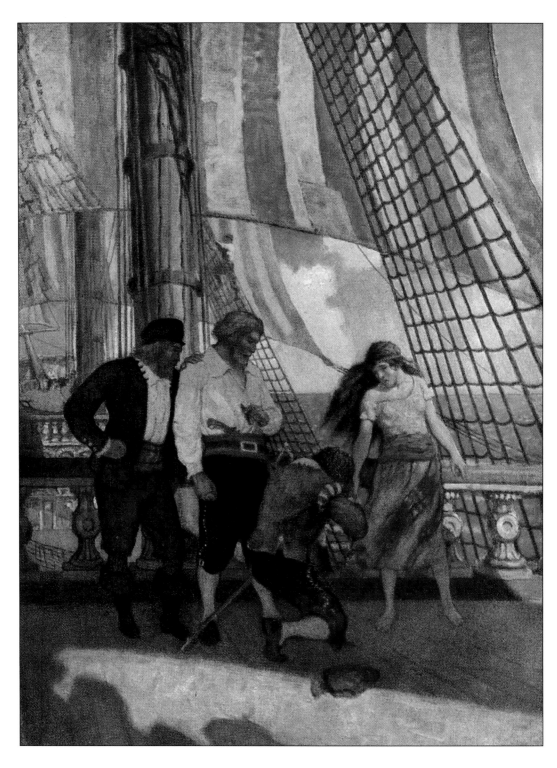

Salvation Yeo finds his little maid again. *Westward Ho!*,
Charles Scribner's Sons, New York, 1920

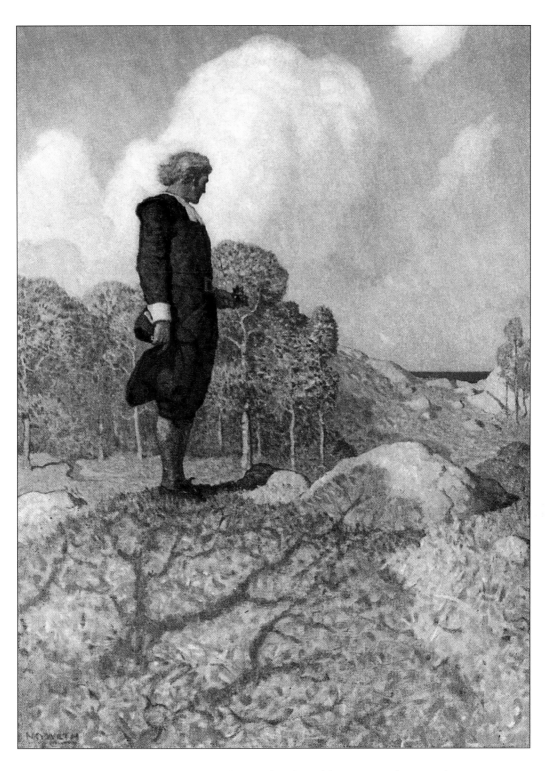

So through the Plymouth Woods John Alden went on his errand.
The Courtship of Miles Standish, Houghton Mifflin Company,
Boston and New York, 1920

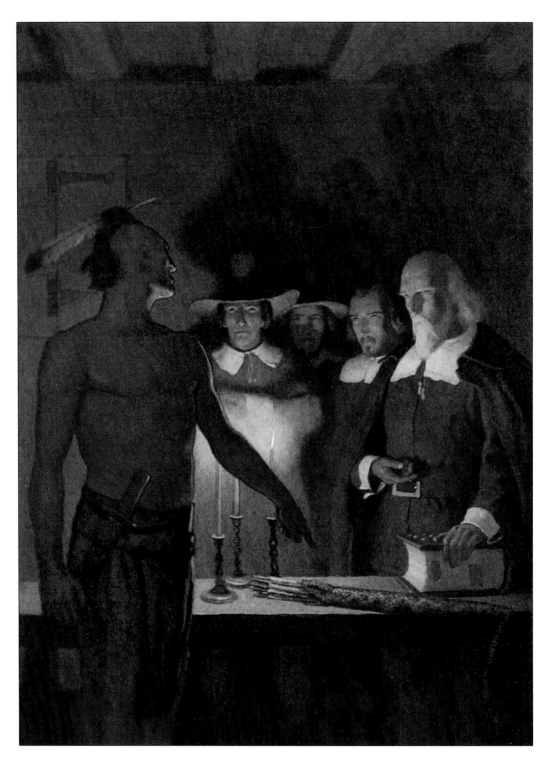

Near them was standing an Indian, in attitude stern and defiant.
The Courtship of Miles Standish, Houghton Mifflin Company,
Boston and New York, 1920

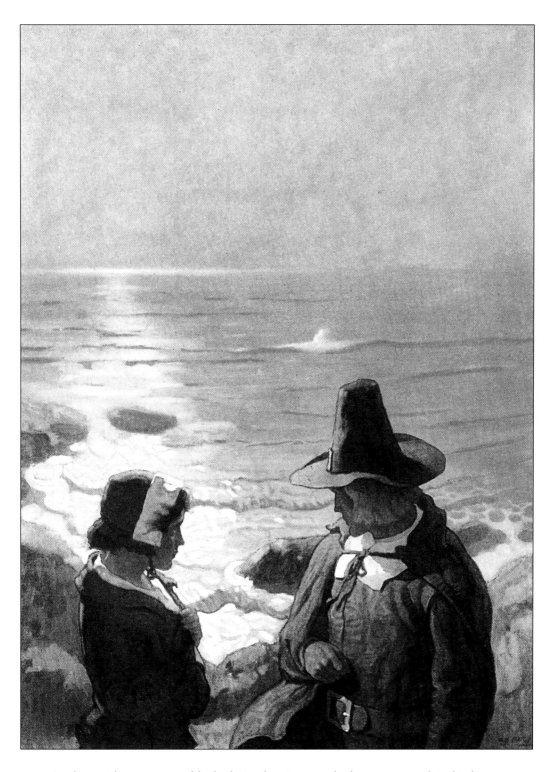

So the maid went on, and little divined or imagined what was at work in his heart,
that made him so awkward and speechless. *The Courtship of Miles Standish*,
Houghton Mifflin Company, Boston and New York, 1920

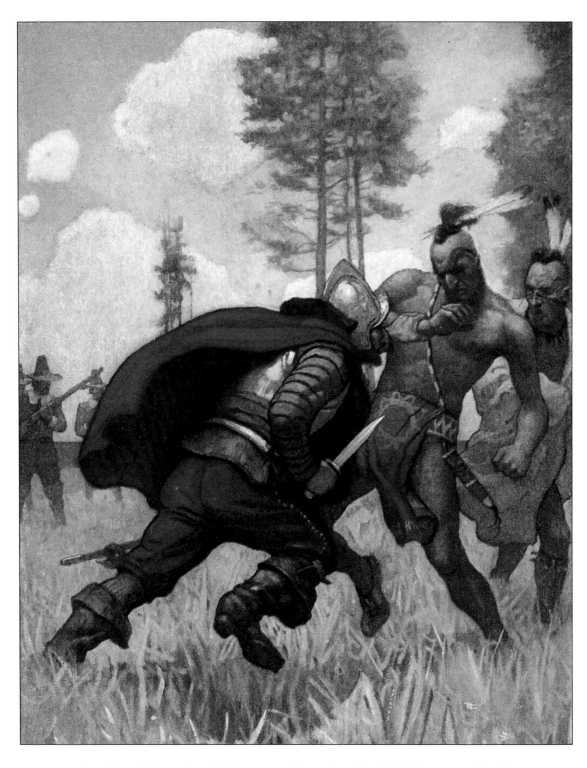

Headlong he leaped on the boaster, and, snatching his knife from its scabbard.
The Courtship of Miles Standish, Houghton Mifflin Company, Boston and New York, 1920

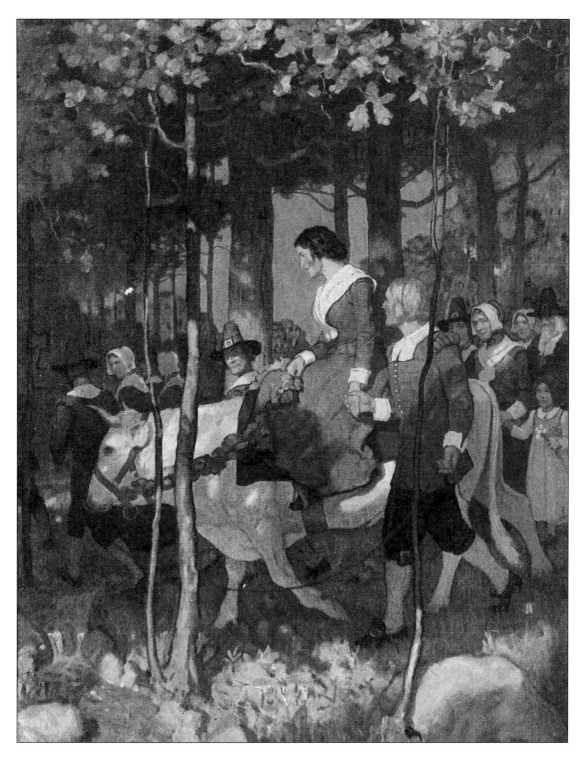

So through the Plymouth woods passed onward the bridal procession.
The Courtship of Miles Standish, Houghton Mifflin Company, Boston and New York, 1920

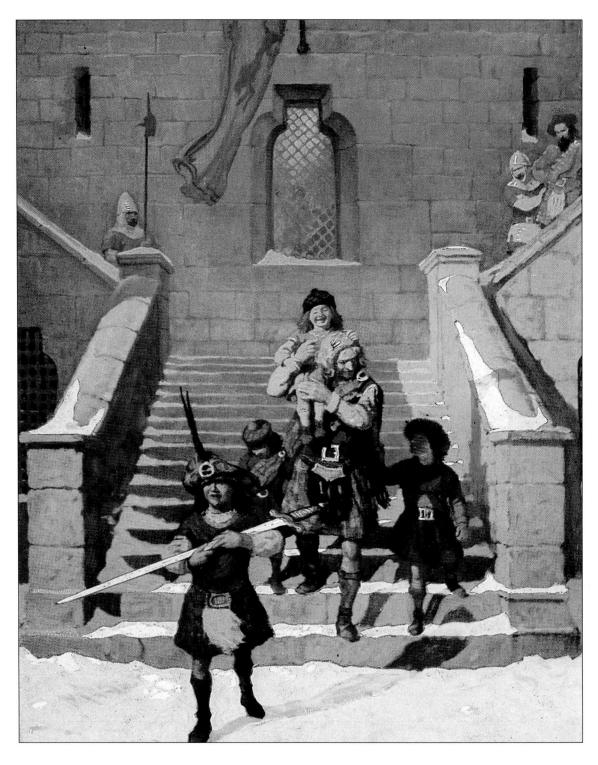

Wallace and the children. *The Scottish Chiefs,*
Charles Scribner's Sons, New York, 1921

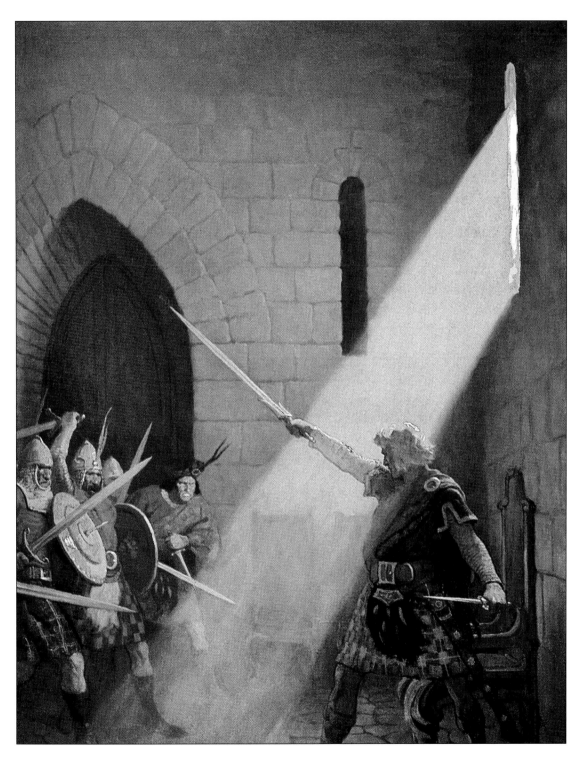

Wallace draws the King's sword. *The Scottish Chiefs,*
Charles Scribner's Sons, New York, 1921

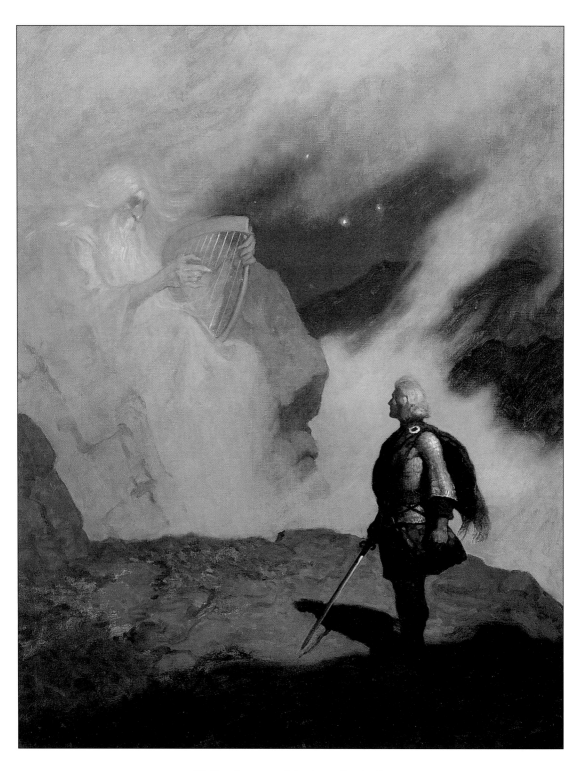

Wallace's vision. *The Scottish Chiefs,*
Charles Scribner's Sons, New York, 1921

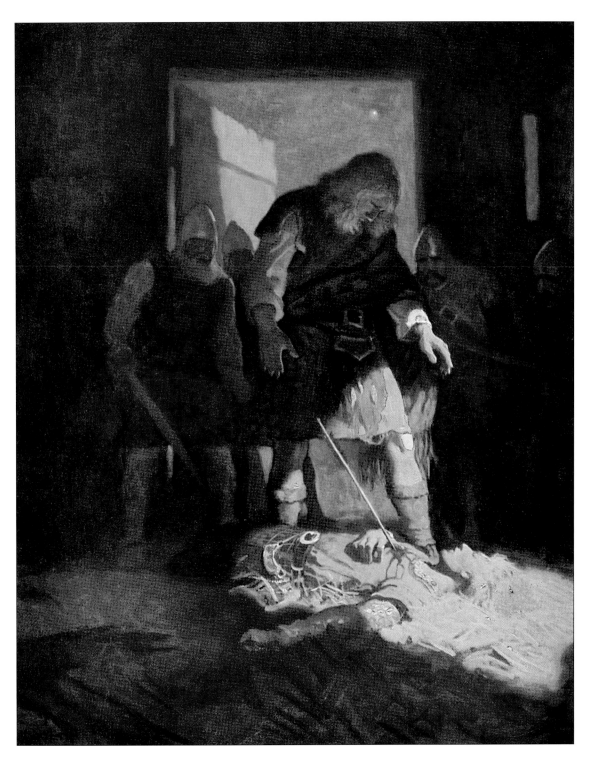

Death of Edwin. *The Scottish Chiefs,*
Charles Scribner's Sons, New York, 1921

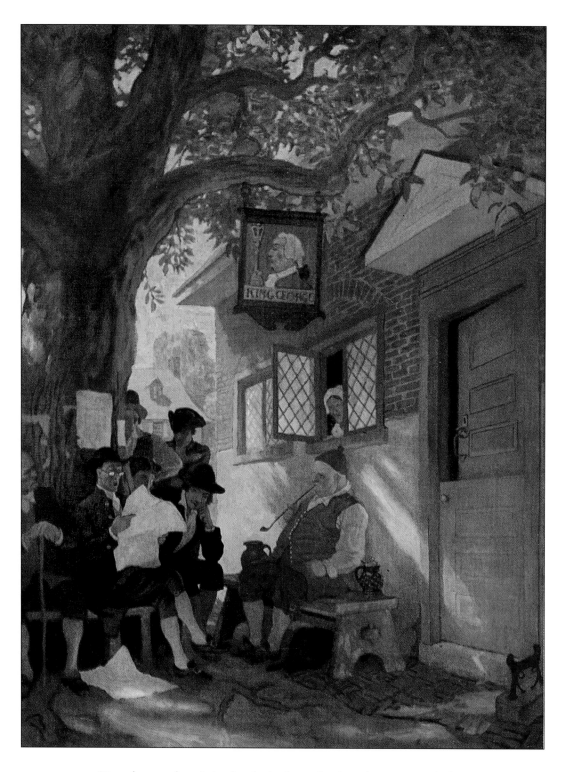

Here they used to sit in the shade through a long lazy summer's day,
talking listlessly over village gossip or telling endless sleepy stories about nothing.
Rip Van Winkle, David McKay Company, Philadelphia, 1921

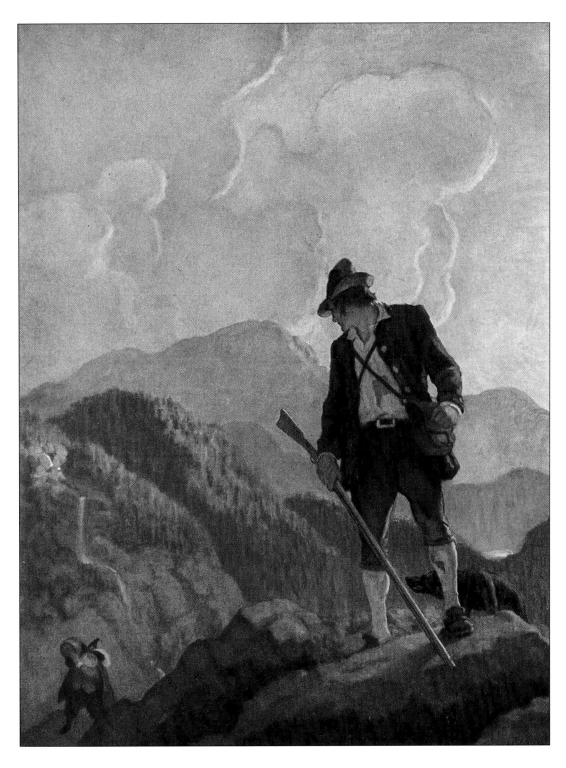

On nearer approach he was still more surprised at the singularity of the stranger's appearance.
Rip Van Winkle, David McKay Company, Philadelphia, 1921

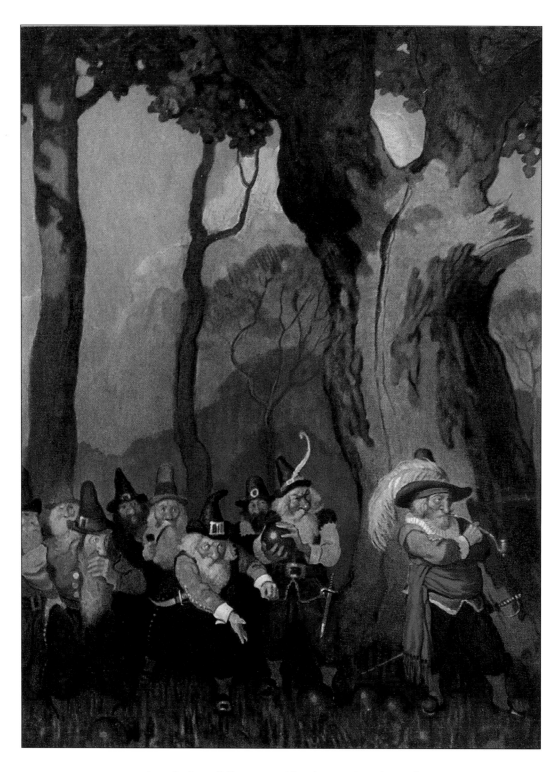

. . . though these folks were evidently amusing themselves,
yet they maintained the gravest faces, the most mysterious silence . . .
Rip Van Winkle, David McKay Company, Philadelphia, 1921

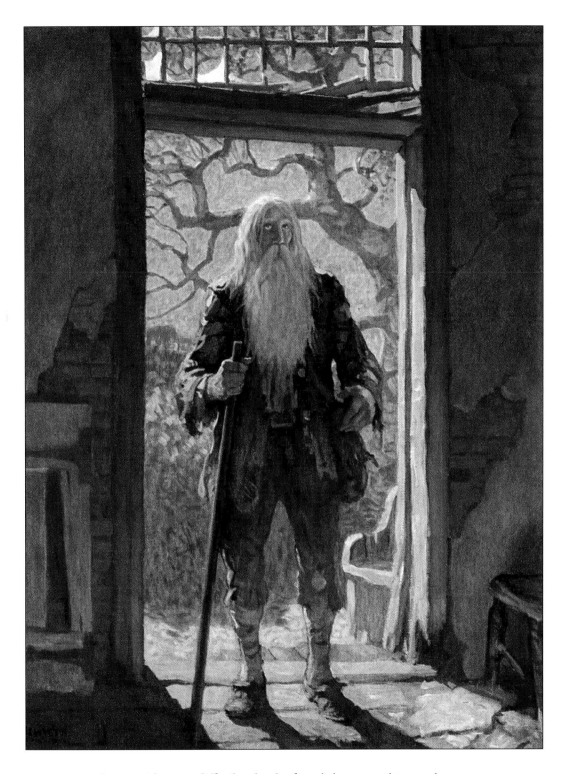

It was with some difficulty that he found the way to his own house,
which he approached with silent awe, expecting every moment to hear the shrill voice
of Dame Van Winkle.
Rip Van Winkle, David McKay Company, Philadelphia, 1921

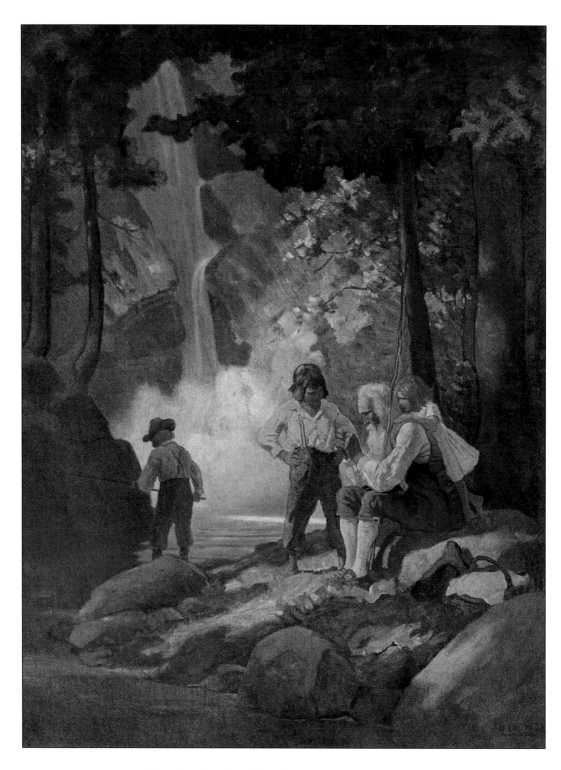

. . . and preferred making friends among the rising generation,
with whom he grew into great favor.
Rip Van Winkle, David McKay Company, Philadelphia, 1921

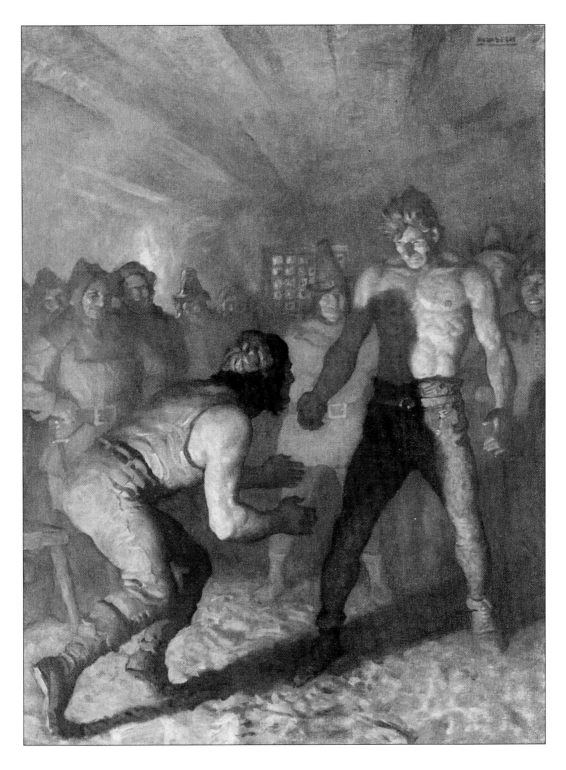

The wrestling match at the "Pied Merlin."
The White Company, Cosmopolitan Book Corporation, New York, 1922

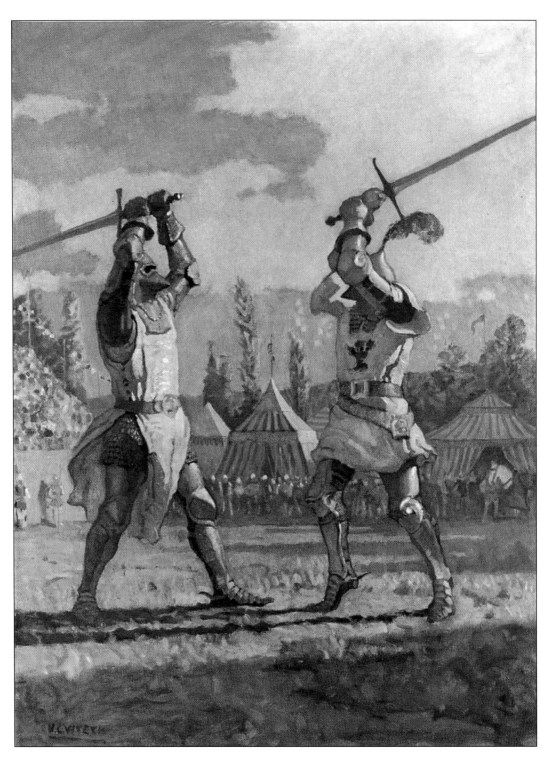

Sir Nigel sustains England's honor in the Lists. *The White Company,*
Cosmopolitan Book Corporation, New York, 1922

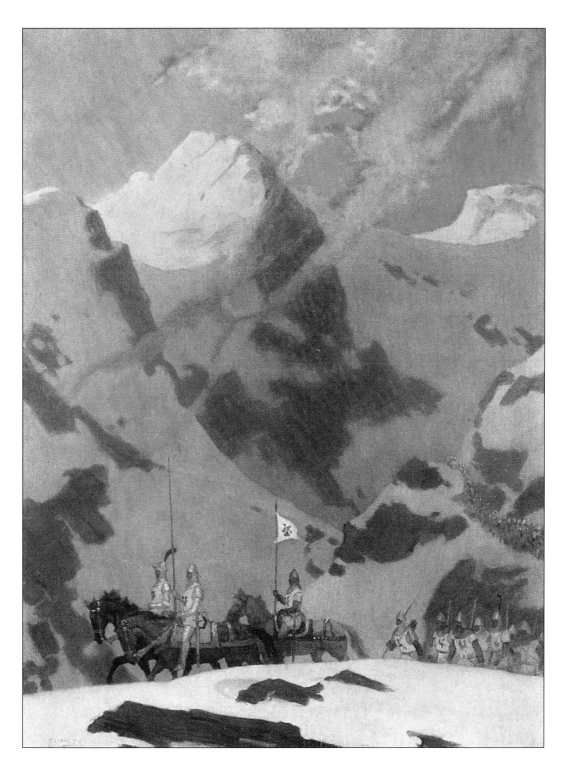

The White Company. *The White Company,*
Cosmopolitan Book Corporation, New York, 1922

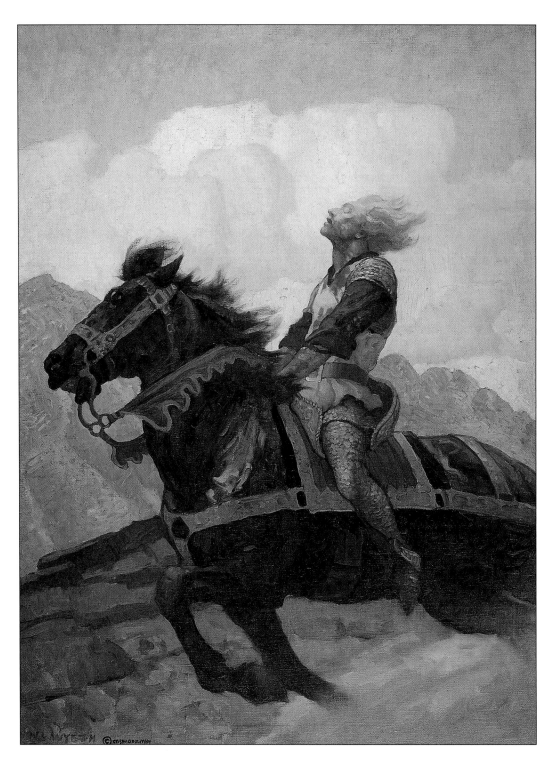

Alleyne's ride with a message for the prince. *The White Company,*
Cosmopolitan Book Corporation, New York, 1922

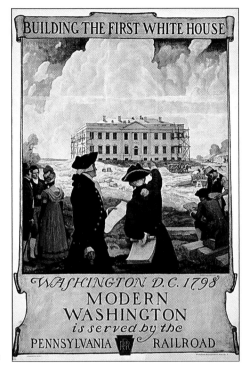

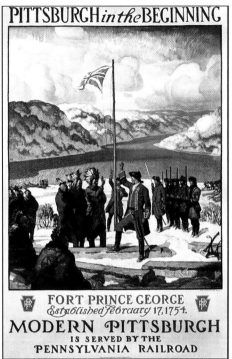

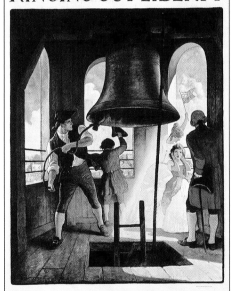

A set of posters done for the Pennsylvania Railroad, Philadelphia, 1930
a. Building the first White House. b. Pittsburgh in the Beginning.
c. Ringing out Liberty. d. In Old Kentucky.

The End